IMAGES
of America

STEAMBOATS ON THE
HUDSON RIVER

For Jim Nordmann, with
very best wishes –

William H. Ewen
11/10/2012

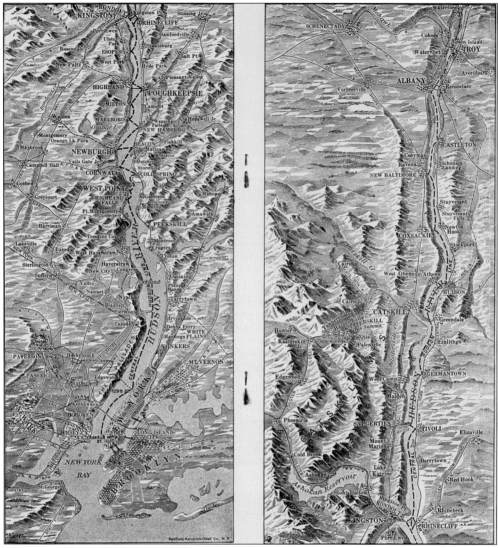

This map is from a 1917 Central Hudson Line brochure. In two sections, it shows the Hudson River from New York to Troy and includes many of the towns served by steamboats over the years. The dotted line traces the route and landings of Central Hudson Line steamers. (Author's collection.)

ON THE COVER: The Hudson River Day Line maintained a small fleet of speedboats at its Indian Point Park to take visitors for rides. The company had this photograph of the big side-wheeler *Hendrick Hudson* taken from one of those speedboats for use in advertising. The image was probably made in the 1930s. (Author's collection.)

IMAGES
of America

STEAMBOATS ON THE HUDSON RIVER

William H. Ewen Jr.

ARCADIA
PUBLISHING

Published by Arcadia Publishing
Charleston, South Carolina

Printed in the United States of America

Library of Congress Control Number: 2010933560

For all general information, please contact Arcadia Publishing:
Telephone 843-853-2070
Fax 843-853-0044
E-mail sales@arcadiapublishing.com
For customer service and orders:
Toll-Free 1-888-313-2665

Visit us on the Internet at www.arcadiapublishing.com

*Dedicated with love to my wife, Susan, and
daughters Chrystena and Amy.*

CONTENTS

ACKNOWLEDGMENTS

I first have to acknowledge my late father, William H. Ewen Sr., for inspiring me with his interests in history, American steamboats, and the Hudson River Valley. My own interests and knowledge began with him. I also want to thank all of the other past historians who recorded and preserved the history of Hudson River steamboats. Their notes, research, letters, articles, books, and photographs were major sources of my research. I specifically want to remember the late Donald C. Ringwald and Roger W. Mabie. They were always very generous in sharing their knowledge, stories, and photographs with me. I am grateful to Peggy Mabie for allowing me the use of photographs from her late husband's collection.

There are others who have my gratitude, and I hope I do not forget anyone. Allynne Lang, curator of the Hudson River Maritime Museum in Kingston, was extremely helpful with information and in allowing me to use images from their wonderful collections. She also wrote the foreword for this book. William G. Muller, marine painter and onetime quartermaster of the *Alexander Hamilton*, allowed me to use photographs from his collection. He also provided firsthand information about the operation of the Hudson River Day Line steamers. Richard Elliott, maritime historian and author, knows as much as anyone about New York excursion boats. I am grateful to him for reading the chapter on excursion boats and making useful suggestions. William DuBarry Thomas, naval architect, historian, and descendant of Newburgh shipbuilders, prepared a fleet list of Hudson River night boats for an unpublished book by my father. This was extremely helpful in my research. My wife, Susan, was a great help by reading the manuscript and making many helpful suggestions. Thanks also to my editor, Rebekah Mower, for her help and patience with a first-time author.

Unless otherwise noted, all images are from the author's collection.

FOREWORD

Hudson River steamboats represented a new form of transportation in America that was revolutionary in its impact. Steamboats were not only a faster form of water transportation than their predecessors the sloops but were also generally more reliable. Until the advent of the railroad in the Hudson Valley around 1845, a Hudson River steamboat was the fastest way to travel between New York and Albany.

From Fulton's first steamboat in 1807, steamboat technology continued to improve, as did amenities for passengers' comfort and enjoyment. In the 1820s, the Hudson Valley began to be painted by artists like Thomas Cole, and travel books with scenes of the river were soon published in Europe. Visitors to New York from Europe knew that a trip by Hudson River steamer to see the beauties of the valley was a must on their itineraries.

The first of the great Catskill Mountain hotels, the Catskill Mountain House, opened in 1824, and those who could afford a vacation traveled to the mountains by steamboat. Hudson River steamboats aimed to be elegant and comfortable, with fine furniture, excellent dining rooms, live music, and fine art on board, but fares were kept low to attract passengers so that everyone could enjoy the experience of seeing the Hudson from one of the beautiful steamers. For those who could not afford a vacation at a mountain hotel, an outing on a Hudson River steamboat represented a one-day mini-vacation. Millions of New Yorkers left the hot city for outings on the steamers. Many groups took annual day trips to upriver parks.

For over 150 years, dozens of Hudson River steamboats carried millions of passengers on pleasant outings on the beautiful and historic Hudson River. Although the last Hudson River side-wheeler, the *Alexander Hamilton*, finished her career of nearly 50 years on the Hudson in 1971, people still have fond memories of trips on the Hudson by steamboat. The legacy of the boats is being preserved for future generations at places like the Hudson River Maritime Museum and in books like this one.

—Allynne H. Lange, Curator
Hudson River Maritime Museum

INTRODUCTION

Steam power was one of the most important forces in the development of this country. It has been called the microchip of the 19th and early 20th centuries. Steam powered pumping stations, railroads, hoisting engines, farm equipment, factories, and of course, ships. Steamboats were able to move people and goods much more reliably and quickly than sailing vessels or horse-drawn vehicles and in greater comfort.

Commercially successful steam boating began on the Hudson River, and it was here that some of the finest examples of inland steamers in the world evolved. Some were internationally famous, while others were known only to those who utilized them or regularly saw them on the river. Each had her own personality and served a specific purpose.

The age of steamboats on the Hudson lasted from the early 1800s until the mid-1970s. Their demise was at first slow but accelerated with the proliferation of trucks and automobiles and the growing use of the diesel engine.

This volume takes a look at the development of steam vessels and the different types that operated on the Hudson. It is not an attempt to give a complete history of steamboats on the river but rather to visually present representative types. Not every line or service could be included, nor every vessel.

The steamboats could not operate successfully without capable crews. Some of the men who manned these vessels are also included here.

Although there were sail-, gasoline-, and diesel-powered vessels operating on the river at the same time as the steamboats, only the steamers are featured here.

One

DEVELOPMENT

Contrary to popular myth, Robert Fulton did not invent the steamboat. There had been earlier experiments, some more practical than others, in this country and abroad. However, none had the funding to keep them going. Fulton earned his fame and place in history by designing and building the first commercially successful steamboat. His genius created a steamboat that did what it was designed to do—carry passengers between New York and Albany, at a profit, without relying on wind or tide. His earlier work on military designs like submarines and torpedoes as well as canals gave him the financial assets to build his steamboat and make improvements. Fulton's partner, Robert Livingston, also put up money, and his considerable political influence helped to ensure that they would not face competition.

An act of the 1807–1808 New York Legislature granted the Fulton-Livingston partnership the exclusive privilege of navigating by steam on the waters of the state. Robert Livingston died in 1813 and Robert Fulton two years later. However, their company, the North River Line, held exclusive rights until 1824. That year, the Supreme Court of the United States declared the monopoly unconstitutional, opening the river for business to anyone who could build and operate a steamboat. This began a time of rapid design and construction advances and led to an age of steamboats on the Hudson that lasted over 160 years.

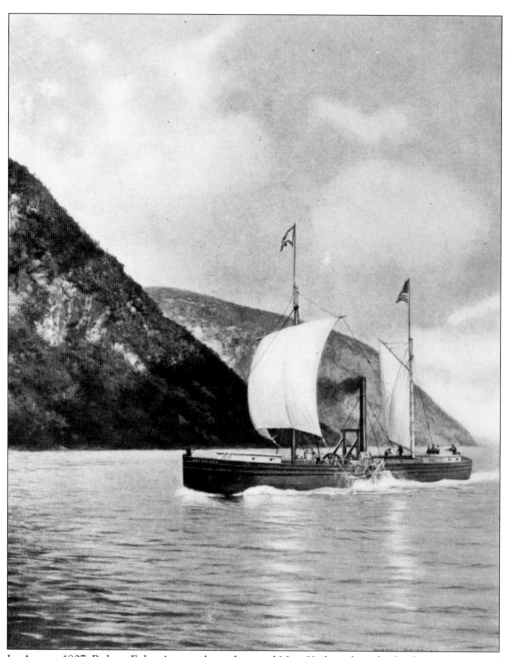

In August 1807, Robert Fulton's steamboat departed New York and made the first trip powered by steam to Albany and back. Over the years, this steamboat has been popularly known as the *Clermont*. There is no evidence, however, that she was ever actually registered in that name. In her 1807 customhouse enrollment papers, she is named the *North River Steamboat*. (The North River was the name the Dutch settlers gave to the Hudson. Most boatmen at New York still refer to the river by that name.) Clermont was the name of the country estate of Robert Livingston and was where the steamboat stopped for the night on her first trip. The name became associated with the steamboat that Livingston had backed financially. As seen in this painting, the vessel was also rigged for sails to take advantage of any favorable winds.

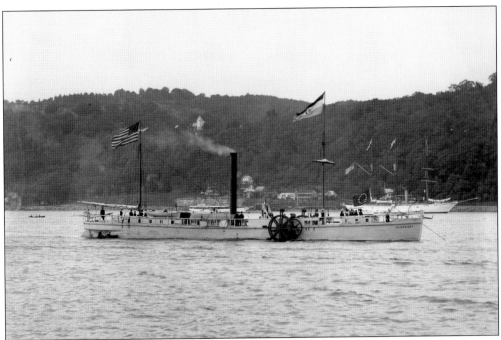

A replica of Fulton's steamboat as first built was constructed for the Hudson-Fulton Celebration of 1909. No original plans, other than machinery, were known to exist, so it was based on known measurements and written descriptions. Although she could travel under her own steam, she was so slow that she had to be towed when traveling any distance as part of the celebrations. (Courtesy of the Ringwald Collection, Hudson River Maritime Museum.)

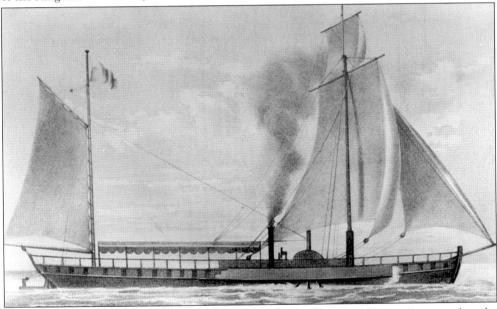

The 1811 *Paragon* was Fulton's third steamboat on the Hudson. At 331 tons (compared to the *North River Steamboat* at 78 tons), she is an example of the rapid advances in design even before steam navigation on the river was open to all builders and operators. The *Paragon* struck a rock, sank, and was abandoned in 1820.

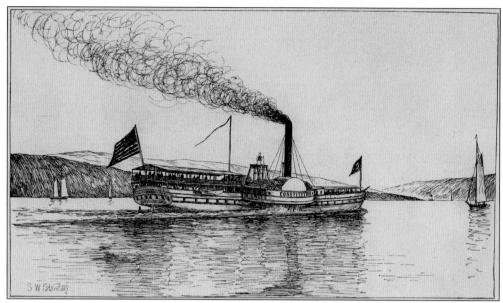

The *Constitution* was built in 1825. At that time, she and a sister ship, the *Constellation*, were considered superior to any other boat on the river. Unfortunately, one of her boilers exploded, killing two people. The *Constitution* was repaired and operated until about 1840. Hulls of early steamboats were basically those of sailing vessels with the deck bulging out around the paddle wheels. (Illustration by S.W. Stanton, *American Steam Vessels*, 1895.)

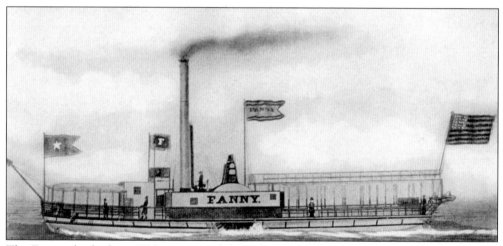

The *Fanny*, also built in 1825, was one of the earliest excursion boats on the river and had no overnight accommodations. The man on the top deck by the smokestack would relay signals from the captain to the engineer by pounding the deck with his cane. Eventually, bells connected directly to the engine room replaced this method. (This 1831 painting by James Bard is from *Old Steamboat Days on the Hudson*, 1907.)

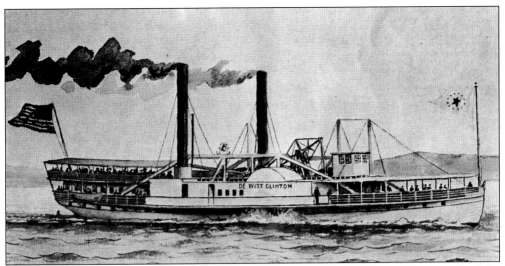

The *DeWitt Clinton* of 1828 shows several advanced features. Her deck was fared out around the paddle wheels from bow to stern (called guards). As a safety feature, her boilers were placed on the guards, rather than in the hull, and she had a walking beam engine. Arching over the paddle wheel is a hog frame. This served to stiffen the wooden hull. (Illustration by S.W. Stanton, *Master Mate and Pilot*, 1909.)

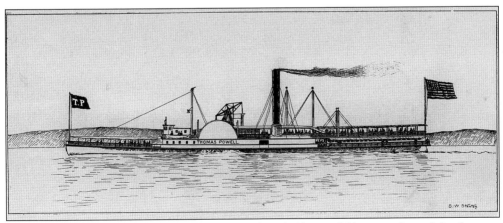

The *Thomas Powell*, built in 1846, displayed the sharp hull, graceful lines, and speed that became characteristic of Hudson River steamboats. In 1846, she made the 60-mile run from New York to Newburgh in two hours and 40 minutes. Her walking beam shows clearly above the paddle wheel. The *Thomas Powell* operated on a number of different runs until scrapped in 1878. (Illustration by S.W. Stanton, *American Steam Vessels*, 1895.)

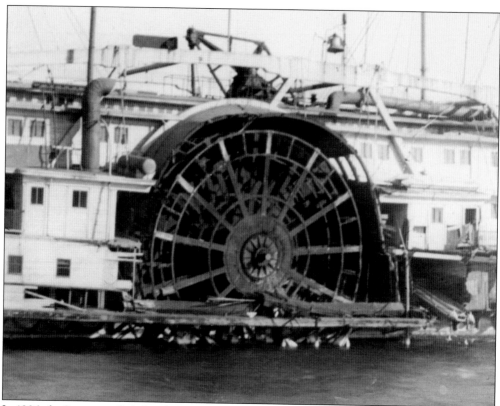

In 1906, the *Saratoga* collided with the *Adirondack*, losing much of her port paddle box and exposing her radial type paddle wheel. As can be seen, radial wheels had fixed paddles (or buckets, as they were called) and had to be quite large to be efficient. This type was in general use on steamers built into the late 1800s, until the advent of the more efficient feathering paddle wheel.

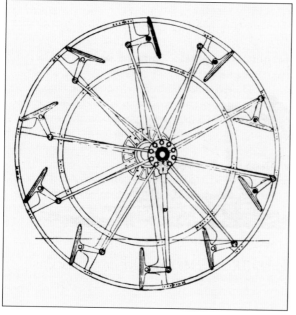

As shown by this drawing, the buckets of the feathering paddle wheel changed angle as the wheel rotated. This enabled them to enter and leave the water almost vertically rather than slapping and lifting water. This efficiency allowed for smaller wheels, and the paddle boxes could be hidden within the superstructure. As the radial wheels disappeared, so did the large, decorated paddle boxes.

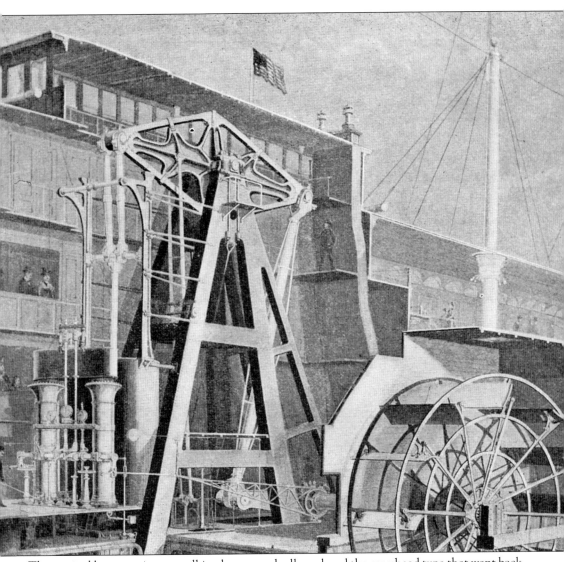

The vertical beam engine, or walking beam, gradually replaced the crosshead type that went back to Robert Fulton's steamboats. These large engines were slow turning because of a long stroke, but the vessels they powered were usually quite fast. When properly maintained, they rarely wore out, and it was not uncommon for one engine to be used in several successive steamers. This cutaway depicts the 3,800-horsepower engine of the night boat *Adirondack*. The beam at the top rocked or "walked" up and down, converting the vertical movement from the cylinders on the left to a rotary motion on the paddle shaft to the right. Clearly visible are the feathering paddle wheel and the engineer's operating platform on the lower left. The walking beam marine engine was strictly an American type. They were used in steamers on bays, rivers, and sounds of both coasts as well as larger lakes—but not on inland rivers like the Mississippi. The beam engines on the few foreign steamers that had them were usually built in this country.

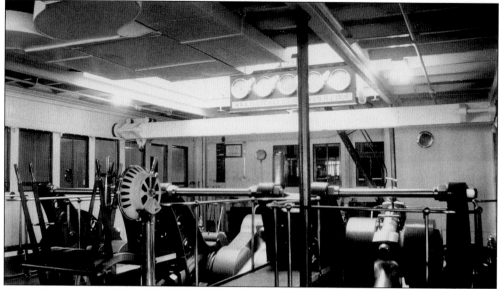

The walking beam was supplanted on side-wheel steamers by the inclined engine. In this type, the cylinders were placed down in the hull. The crankshafts were set at an inclined angle up to the main deck level where the cranks connected to the paddle wheel shaft. Many passengers remember standing at the windows on the main deck and watching the motion of the cranks. Above is the engine room of the *Hendrick Hudson*. Two of her three cranks are visible at the center and right. Screw propellers appeared in the 1800s but did not replace the side-wheelers. Each had distinct advantages. Below is the four-blade propeller of the *Peter Stuyvesant* of 1927. She is in dry dock being readied for the 1938 season. (Above, photograph by Donald C. Ringwald; Hudson River Maritime Museum.)

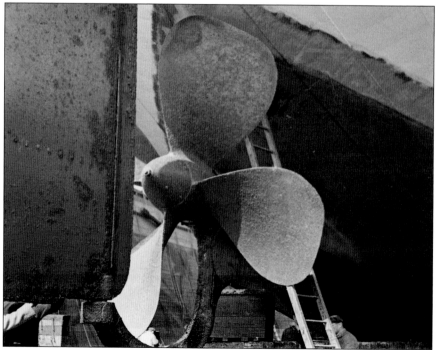

Two

NIGHT BOATS

The earliest steamers running between New York and Albany, including the *North River Steamboat*, had overnight accommodations for passengers. Because of their slow speed, they were unable to complete the trip during the day. It often took a day and a night. However, the steamers that were considered true night boats ran on a schedule of overnight service. Before long, the boats were fast enough to complete the full trip in one night, including making landings along the way. One steamer would leave New York in the evening, while a running mate would leave Albany or Troy, each arriving at her destination early the next morning. As one company's advertising stated, "Go by night and save a day."

With the advent of the railroad along the Hudson in the 1850s, steamboats were no longer the fastest means of travel. They met the competition by promoting comfort. The railroads were noisy, bumpy, and dirty. By contrast, night boats became larger and more luxurious and featured fine meals. They could be compared to the finest hotels of the day.

Although the night boats from New York to Albany and Troy were the largest and best known, night lines ran out of other towns and cities, including Newburgh, Kingston, Saugerties, and Catskill.

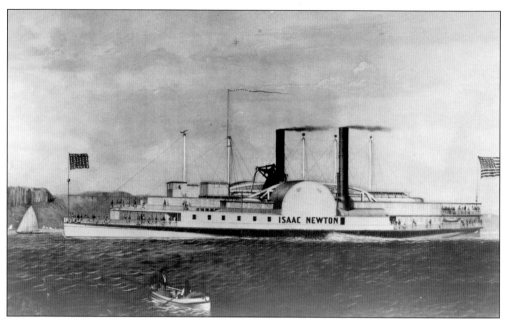

The *Isaac Newton* was under construction as a day boat when she was purchased by the North River Association (the People's Line) for use as a night boat. From 1846 to 1863, she operated in overnight service between New York and Albany. In 1855, the steamer was lengthened and enlarged. She exploded and burned in 1863, about where the George Washington Bridge is now. This lithograph shows the vessel as originally built.

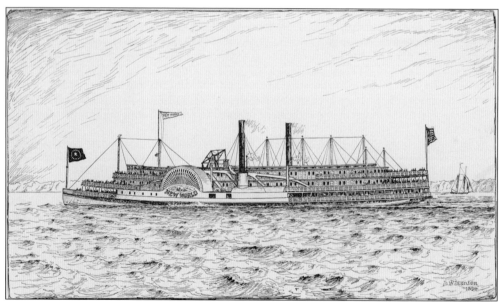

The *New World* was built for a new day service of the People's Line, but in 1855, she was enlarged and converted to a night boat, the largest in the country. She was the first to have double tiers of staterooms. From 1855 to 1864, the *New World* operated mostly opposite the *Isaac Newton*. With the engine removed in 1864, she served as a Civil War hospital in Virginia. (Illustration by S.W. Stanton, *American Steam Vessels*, 1895.)

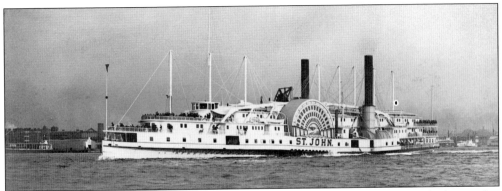

The *St. John* was built for the People's Line in 1864 at Greenpoint, New York. She had a wooden hull, and her engine had formerly been in the steamer *New World*. With an overall length of 418 feet, the *St. John* was the largest inland steamer in the world at the time. Capt. A.P. St. John, for whom she was named, had been an important figure in the People's Line from its inception in 1834. The steamer operated in the overnight service between New York and Albany until 1884. During winter lay-up in January 1885, she burned at her New York wharf. The interior view below shows the main saloon, looking forward. The columns are actually masts that pass down through the superstructure to the hull.

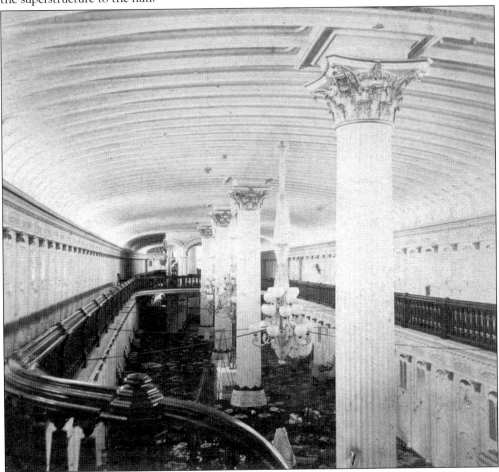

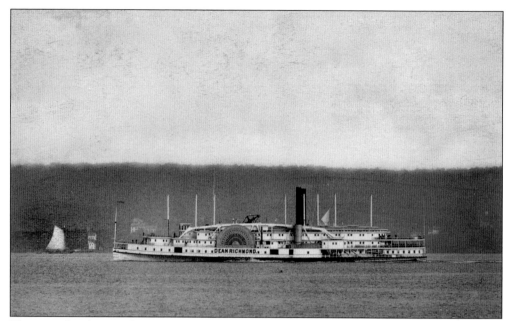

The year after the *St. John* was built, the People's Line built the *Dean Richmond*. The two became running mates in the New York–Albany service until the delivery of the *Drew* in 1867. After that, two of the three ran opposite each other, with the third being a spare. The *Dean Richmond* continued on this run, and then for her last two years was in service to Troy.

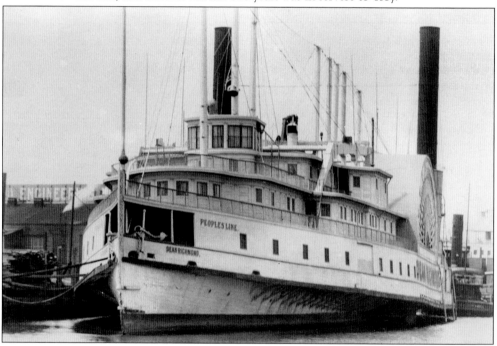

In this view, the *Dean Richmond*, named for a president of the New York Central Railroad, appears to be out of service. There are extra lines out to the wharf and no signs of life. She last operated in 1908 and in 1909 was sold and scrapped at Boston. The engine came from the 1851 *Francis Skiddy*.

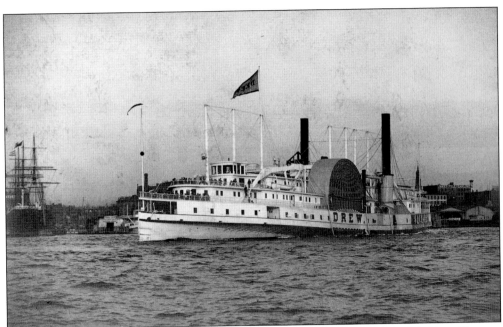

In 1867, the yard of John Englis delivered a third new steamer for the People's Line. She was named *Drew* in honor of Daniel Drew and was partnered with the *St. John* and *Dean Richmond*. They were very similar in design, but the *Drew* apparently had the most elegant interior. She was retired in 1903. This image shows the steamer departing New York for Albany. (Photograph by Gubelman; author's collection.)

The *Sunnyside* and a sister ship, *Sleepy Hollow*, were built in 1866 as day boats. In 1870, the *Sunnyside* was sold to three partners and converted to a night boat. Later, the partners formed the Citizen's Line between New York and Troy. The *Sunnyside* sank in the ice while on this run on December 1, 1875, with the loss of 11 lives. This view shows her at Troy.

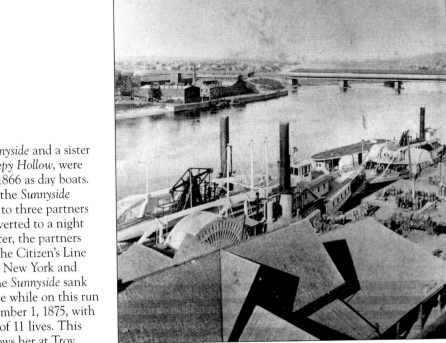

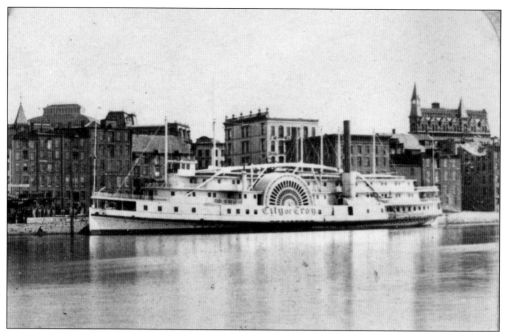

The *City of Troy* was launched on April 1, 1876, and made her first overnight trip between New York and Troy on June 14. She continued in this service until 1907. At different times, she ran opposite the steamers *Thomas Powell*, *Saratoga*, and *Greenport*. The *City of Troy* is shown here at her wharf in Troy, several miles above Albany.

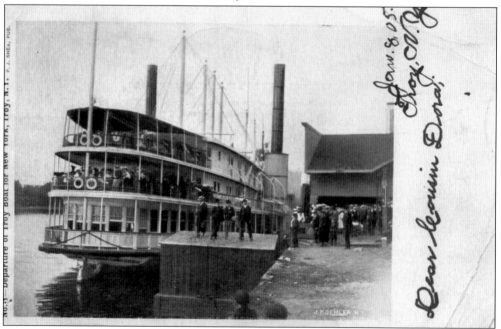

This postcard, dated January 8, 1905, depicts the stern of the *City of Troy* as the steamer gets ready to depart Troy for New York. There was always a lot of activity as the steamer got ready to sail. Freight and passengers went aboard, and people crowded the wharf to see friends off. She would have to turn around before heading down river.

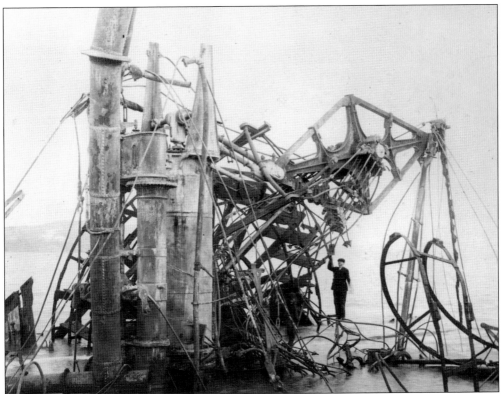

On the evening of April 5, 1907, the *City of Troy* caught fire on her way upriver. Capt. Charles Bruder brought her into Dobbs Ferry, where the crew and local men were able to save all passengers. This is all that remained. The engine was originally in the *Firecracker*, which had operated in China. This engine was later shipped back to the United States.

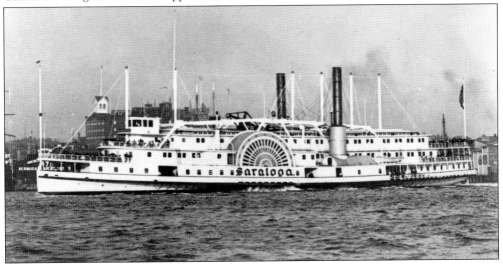

In 1877, another large wooden night boat was delivered to the Citizen's Line. The *Saratoga* replaced the steamer *Thomas Powell* on the New York to Troy run. Her engine came out of the steamer *Sunnyside*. The *Saratoga* is shown here early in her career heading upriver past the burgeoning New York skyline.

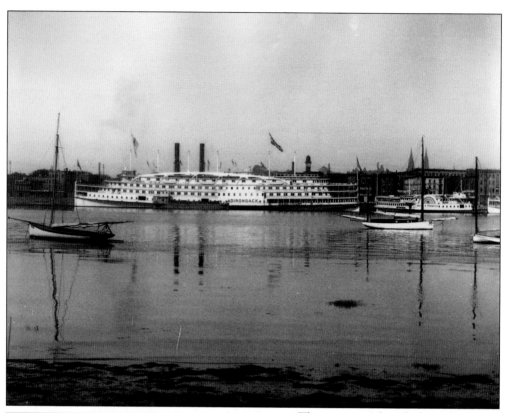

The steamer *Adirondack* was built in 1896 for night service on the People's Line to Albany. Although she has a hog frame, other characteristics of earlier steamers had disappeared by this time. The boilers are in the hull with smokestacks amidships. The *Adirondack* also has the smaller feathering paddle wheels, which are hidden within the cabin work. She was laid up at Athens in 1918 and scrapped in 1925.

The *Adirondack*, at 412 feet in overall length, was one of the largest wooden vessels ever built. Wood was used for the hull to lighten her draft. At the time she was built, the upper river was still too shallow to accommodate an iron-hulled vessel of this size. This view is of her pilothouse from the bow. She has the graceful curved deck lines so typical of these steamers.

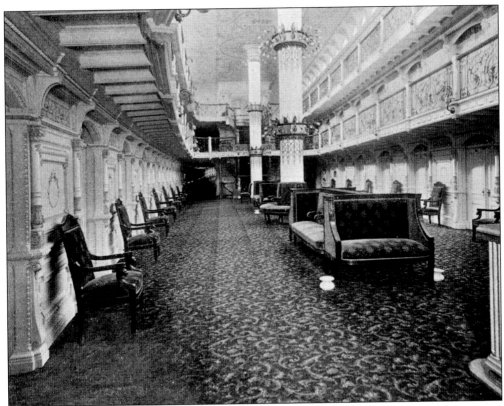

This is the large and comfortable main saloon of the *Adirondack*. She had three levels of staterooms running along both sides, and her masts are decorated like columns. Spittoons are in evidence. In 1901, the People's Line (New York–Albany) and the Citizen's Line (New York–Troy) were purchased by Charles W. Morse, and the *Adirondack* became his property. In 1905, the lines were combined as the Hudson Navigation Company.

The system of electric lighting on the *Adirondack* was the largest of any vessel afloat at the time. Three direct current generators powered 1,900 incandescent lights and a 24-inch marine searchlight on the pilothouse. This shows the generator room. There is a bicycle tucked behind the switch panel. It was probably used for running errands when the ship was in port.

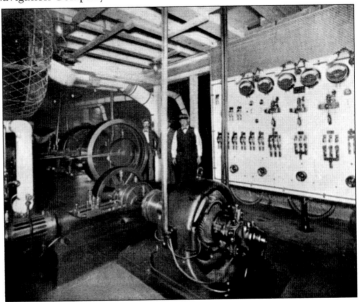

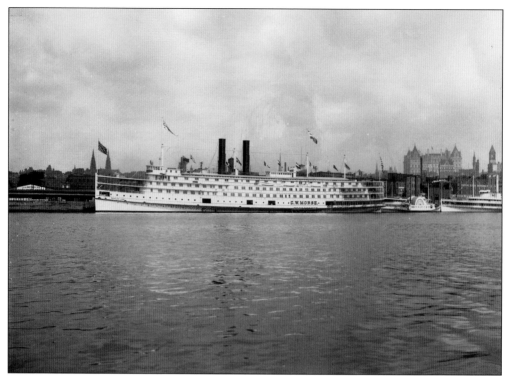

In 1904, the side-wheel steamer *C.W. Morse* went into service on the Hudson Navigation Company's People's Line to Albany. Unlike her predecessors, she had a steel hull and, at 427 feet overall length, was the largest on the river. She is seen here at Albany when quite new. Aft of the *C.W. Morse* are the steamers *M. Martin* and *New York*. The large building is the state capitol.

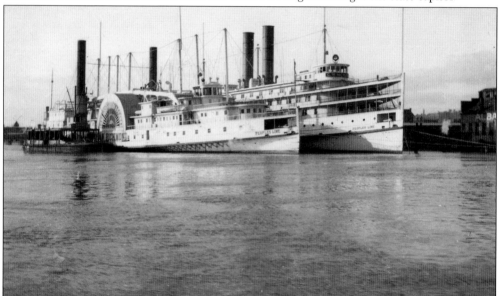

This interesting view shows the 1865 *Dean Richmond* rafted to the *C.W. Morse* at Albany. It clearly shows how design and size had changed over 40 years. The *Dean Richmond*, with her hog frame, boilers on deck, and large paddle boxes, is clearly from a different era.

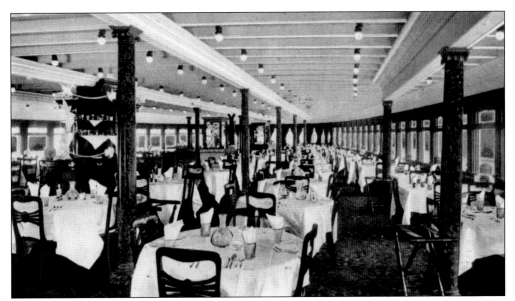

The large, elegant dining room of the *C.W. Morse* was located on the main deck at the stern. As seen in this postcard view looking aft, large windows surrounded the room. During the summer when daylight lasted longer, the river scenery could be enjoyed while having dinner.

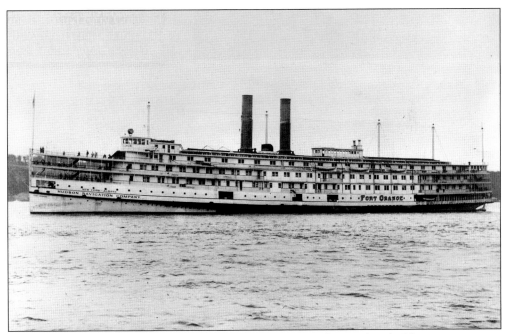

From December 1917 through early 1919, the *C.W. Morse* was chartered to the Navy as a receiving ship and barracks for World War I recruits. In 1922, after Charles W. Morse was convicted of bank fraud, the steamer was renamed *Fort Orange*. In 1928, she was laid up at Athens and seven years later was sold for scrap. The hull was taken to Bridgeport, Connecticut, for use as a breakwater.

In 1909, the Hudson Navigation Company built two sister ships, the *Trojan* and the *Rensselaer*, for its Citizen's Line service to Troy. Both had steel hulls and were 330 feet in overall length. This is one of the ships, probably the *Trojan*, just after launching at the T.S. Marvel shipyard in Newburgh. She was next towed to the W&A Fletcher yard in Hoboken for installation of her engine, boilers, and paddle wheels.

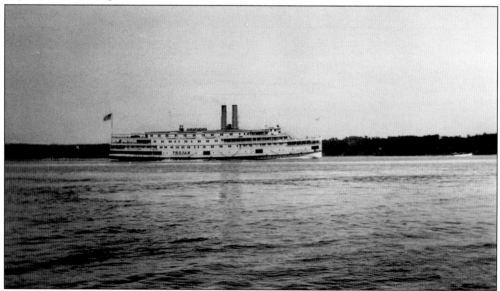

The *Trojan* was launched on October 26, 1908, and went into service in April 1909. She operated in the overnight service between New York and Troy until 1927. In the spring and fall, when traffic was lighter, she and her sister ship would take over the New York–Albany run. (Photograph by Donald C. Ringwald; author's collection.)

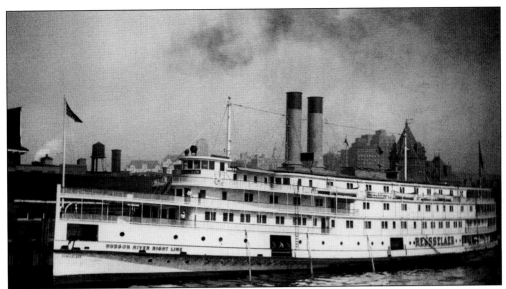

The *Rensselaer* joined the *Trojan* in New York–Troy service later in 1909, running opposite each other through the 1927 season. After 1928, they served both Albany and Troy, stopping at Albany in each direction. This view shows the *Rensselaer* at Albany in the 1930s. By the time of this photograph, the Hudson Navigation Company was called the Hudson River Night Line. (Photograph by Roger W. Mabie; courtesy of the Mabie family.)

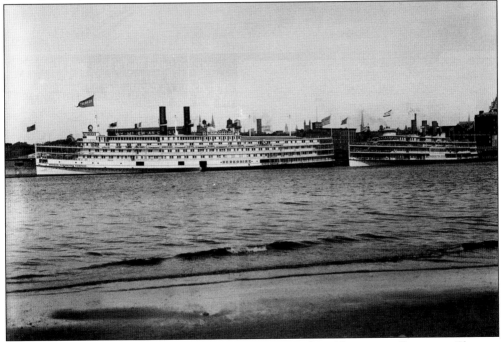

In 1907, the steamer *Princeton* was launched for the Hudson Navigation Company. She was then laid up until 1912, when she was completed as the *Berkshire*. At 440 feet overall length, she was the largest river steamer ever built in the world. She was licensed for 2,493 passengers and could carry 200 automobiles or the equivalent in freight. Here, the vessel is at Albany with the *Washington Irving* behind her.

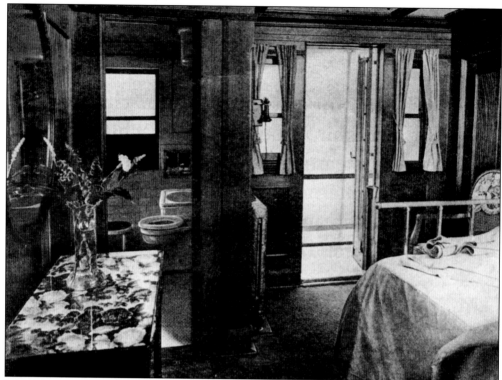

Like other night boats, the *Berkshire* had a number of parlor suites and bedrooms. However, the majority of her staterooms were much smaller, with upper and lower berths and no private bath. This view of a parlor suite is from a 1914 issue of the company's magazine, the *Searchlight*.

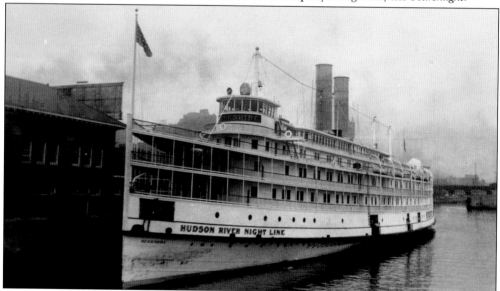

This August 27, 1935, image shows the *Berkshire* resting at her Albany wharf before departing for New York later in the evening. At the end of this season, she would be laid up for a year at Athens. In 1937, the *Berkshire* was brought out once again to run opposite the *Trojan*. (Photograph by Donald C. Ringwald; Hudson River Maritime Museum.)

The *Berkshire* never ran after the 1937 season and was laid up at Athens. In January 1941, she was towed to Hoboken. In this view, the steamer is passing Poughkeepsie under tow. Sold to the War Department, she was towed to Bermuda, where she was used as a barracks for workers building an Army base there. She was finally scrapped at Philadelphia in 1945. (Photograph by Donald C. Ringwald; author's collection.)

In 1935, the Night Line had been purchased by Samuel Rosoff and service to Troy eliminated. In 1935 and 1936, the *Trojan* and the *Rensselaer* ran to Albany; 1936 was the *Rensselaer's* last year. In 1937, the *Trojan* ran opposite the *Berkshire*. In 1938, the Night Line did not operate, and the *Trojan* was laid up with her sister, as shown here. (Photograph by Roger W. Mabie; courtesy of the Mabie family.)

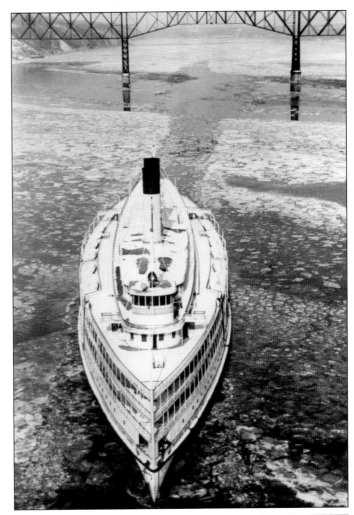

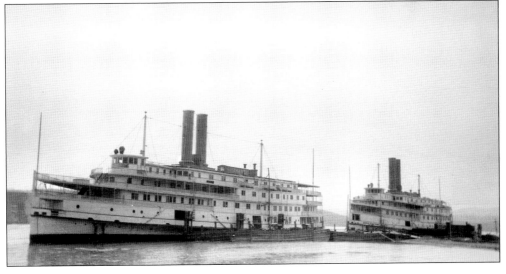

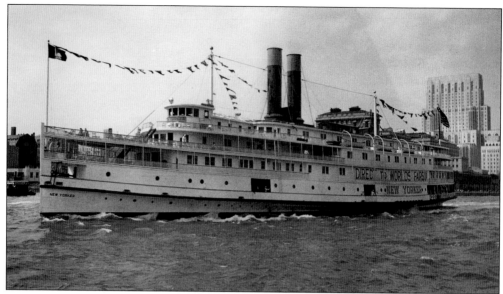

Because of anticipated traffic for the 1939 New York World's Fair, the Night Line revived the New York–Albany service. The *Trojan* was taken out of lay-up and renamed the *New Yorker*. She operated the overnight service by herself and, on days in New York, ran to the fair. She is seen here in the East River. The large building is the Cornell Medical Center. (Photograph by Donald C. Ringwald; author's collection.)

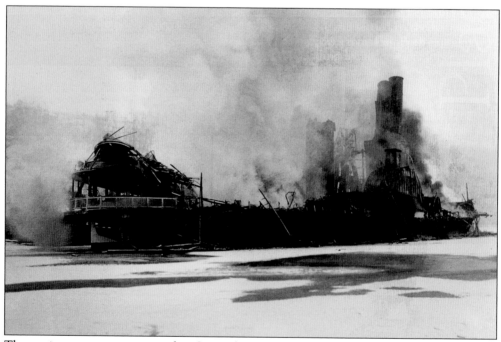

The service was not a success, and on September 4, 1939, the *New Yorker* made the last scheduled trip of any overnight steamer on the Hudson River. She went back into lay-up at Marlboro, a few miles below Poughkeepsie. During a snowstorm on March 1, 1940, she mysteriously caught fire and was destroyed. Not long after, she sank and remains under the river to this day.

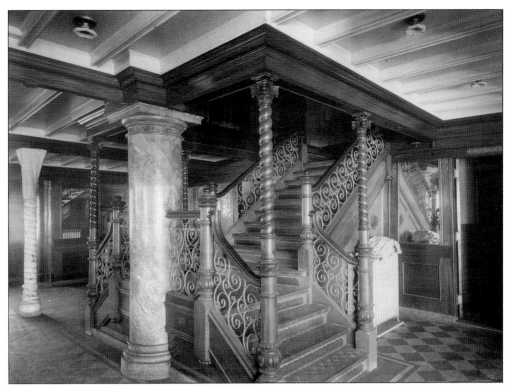

After the *New Yorker* burned, the *Rensselaer* remained at Marlboro for two more years. She was considered for government use but was not suitable. In 1942, the steamer was towed to Providence, Rhode Island, to be scrapped. The two views on this page were taken on board at Providence before work began. The photograph above shows the quarterdeck, where passengers would have come aboard. The purser's office is on the far bulkhead, partially hidden by the railing. The door on the right was the baggage room. The photograph below shows a portion of the freight deck. Automobiles as well as freight were carried here. The *Rensselaer's* hull was taken to Chesapeake Bay, where it was used as a barge for many years. (Both, photographs by William K. Covell; author's collection.)

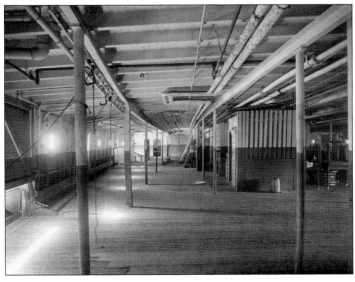

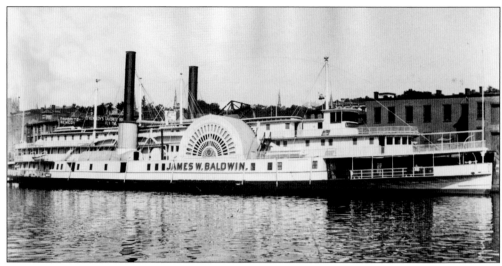

The Central-Hudson Line was formed in 1899 by merging night lines that operated between Newburgh and New York, Poughkeepsie and New York, Kingston and New York, as well as a Newburgh–Albany day line. The line from Kingston (Romer & Tremper) was based in Rondout Creek. The older of the company's two steamers was the 1861 *James W. Baldwin*, shown here at Rondout. (Roger W. Mabie collection; courtesy of the Mabie family.)

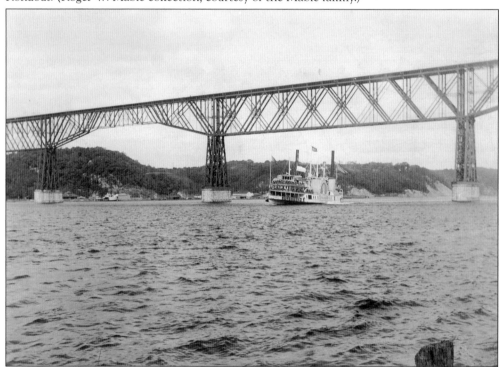

In 1903, the *James W. Baldwin* received new boilers and electric lights. Her name was changed to *Central-Hudson*. In 1911, after 50 years on the Rondout (Kingston) overnight run, she was retired. This view shows her under the Poughkeepsie railroad bridge on a special daylight trip as part of the Hudson-Fulton Celebration in 1909. The decks are crowded with passengers, and the vessel is flying the Hudson-Fulton flag.

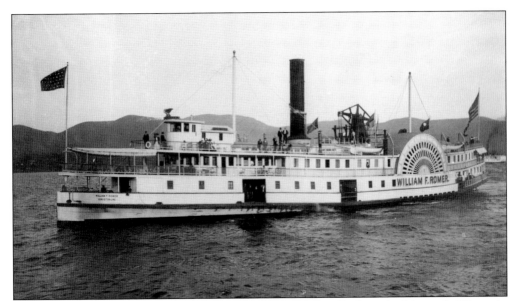

Romer & Tremper's other steamer was the *William F. Romer*. Built as the *Mason L. Weems* in Baltimore in 1881, she carried freight and passengers between Baltimore and Fredericksburg, Virginia, until 1890. It was found that her draft was too deep for that route, so she was sold for use on the Hudson River. (Roger W. Mabie collection; courtesy of the Mabie family.)

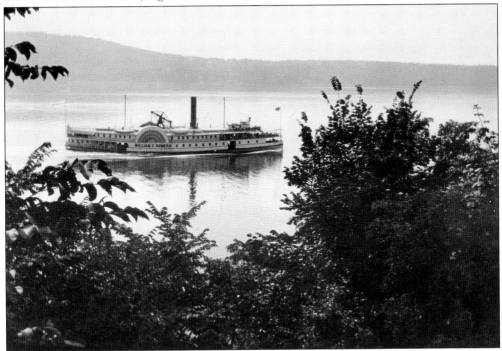

The *Mason L. Weems* was renamed *William F. Romer* when she came to the Hudson to run opposite the much larger *James W. Baldwin*. The *William F. Romer* was laid up after the 1918 season and finally dismantled in 1922. Her hull was taken to Eavesport, New York, for use as a wharf, and the timbers are still there. This photograph shows the steamer passing Hastings-on-Hudson on a quiet evening in August 1899.

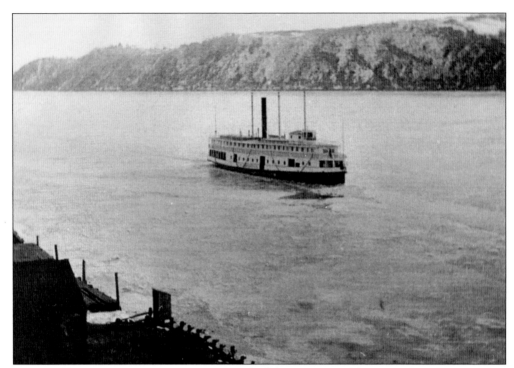

The Poughkeepsie Transportation Company, which became part of the Central-Hudson Line, had two similar steamers. The *Daniel S. Miller* was built in 1862 and the *John L. Hasbrouck* in 1864. They were more utilitarian in appearance than graceful. One thing that made them quite unique was that both had small walking beam engines, even though they were propeller steamers. They could carry overnight passengers but were primarily freight boats. In 1900, the *John L. Hasbrouck* was renamed *Marlboro* and the *Daniel S. Miller* renamed *Poughkeepsie*. The *Marlboro* was retired after 53 years of service and scrapped in 1918. The *Poughkeepsie* burned in 1910. The above view shows the *John L. Hasbrouck* following a channel in the ice. The wonderful image below shows her as the *Marlboro*, loading peaches at Milton. (Below, courtesy of the Ringwald Collection, Hudson River Maritime Museum.)

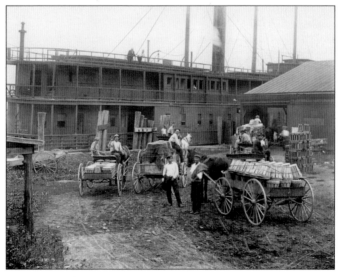

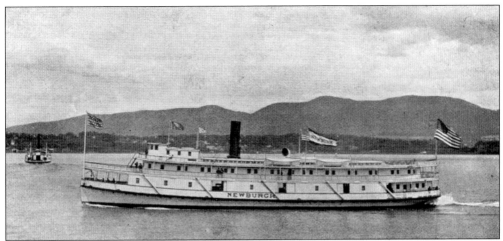

The Homer Ramsdell Transportation Company's service between New York and Newburgh also became part of the Central-Hudson Line in 1899. The company operated two 212-foot iron-hulled propeller steamers. The *Newburgh* was built at Philadelphia in 1886 and is shown off her namesake city when fairly new. The higher peak in the background is Mount Beacon, so named because of signal fires placed there during the American Revolution.

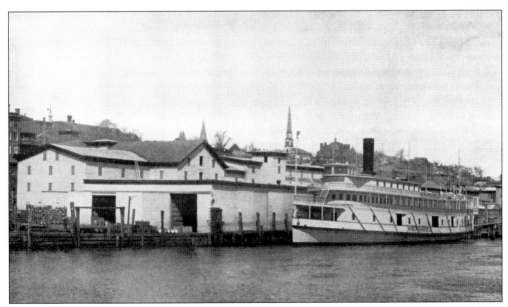

The company's other steamer was the *Homer Ramsdell*, built in 1887 at Newburgh. She is seen here, as originally built, at the wharf in Newburgh. The large covered shed indicates the importance of freight. These smaller night boats made many more landings than the larger steamers, and the Central-Hudson Line served more towns than any other line on the river.

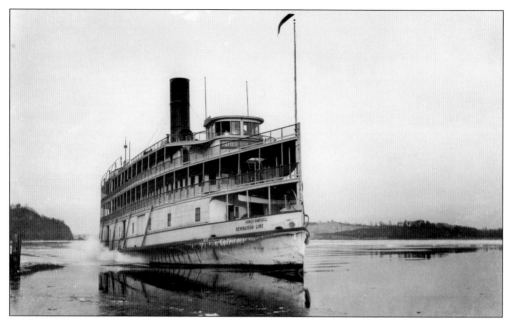

In this winter view, the *Homer Ramsdell* is approaching a landing, with ice on the bow and hanging from the guards. She is a bit shabby from hard winter service but will go into the shipyard for painting and maintenance before the next season. By this time, the third deck has been extended all the way to the bow. (Photograph by Ralph P. Young; courtesy of the Hudson River Maritime Museum.)

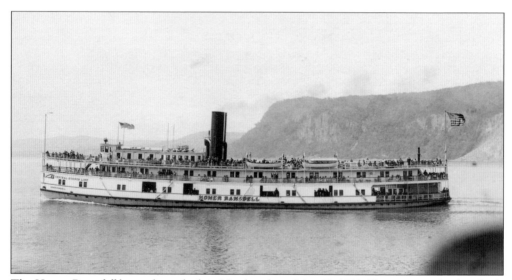

The *Homer Ramsdell* burned at a dock in Newburgh on May 21, 1911. She was completely rebuilt the same year, partially using material from the retired *Central-Hudson*. This view shows her after she was rebuilt, heading south in Haverstraw Bay with an excursion. In addition to their scheduled service, these steamers were often used for excursions and special charters.

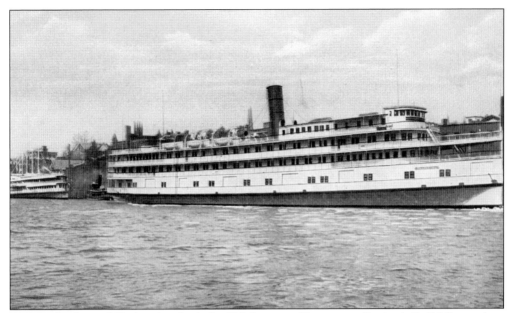

In 1911, the Central-Hudson line built the 280-foot propeller steamer *Benjamin B. Odell* to replace the *Central-Hudson*. She had a large freight and passenger capacity, and with a strengthened steel hull, she proved remarkably able to operate in the ice. In this postcard view, she dominates the waterfront at her Kingston wharf on Rondout Creek. Behind the *Benjamin B. Odell* is the *Mary Powell*.

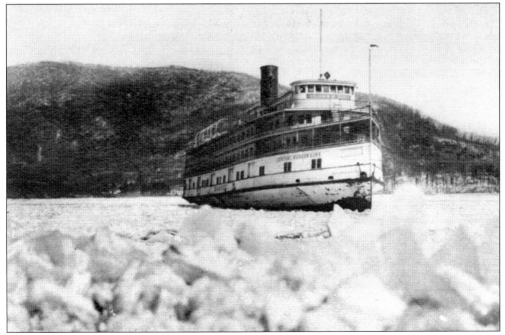

This image of the *Benjamin B. Odell* shows her navigating through the ice in 1929. The ice has scraped the paint off the bow. By the 1920s, trucks had started making inroads into the freight business. Steamers that relied on the revenue from freight tried to operate year round. Once shippers switched to trucks during the winter, they often stayed with the trucks.

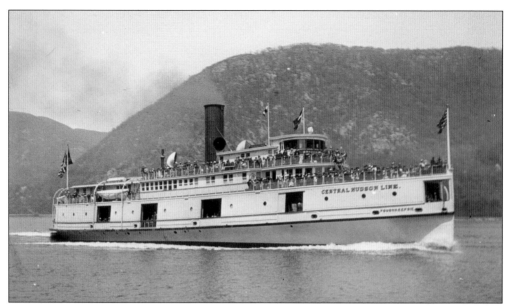

In 1917, a new 215-foot propeller steamer was delivered to the Central-Hudson Line. She was named *Poughkeepsie* for the mid-Hudson city that was served by the line. The steamer had excellent freight facilities, but her passenger accommodations were limited. Below, she is tied to the bulkhead at Troy on a summer afternoon. The *Poughkeepsie* and *Benjamin B. Odell* were purchased in 1935 by Samuel Rosoff, the same year he purchased the Hudson River Night Line. In 1937, the *Poughkeepsie* was sold to the Meseck Line, converted to an excursion boat, and renamed *Westchester*. She was taken by the government in 1942, steamed to Brazil, and ended her days on the Amazon River.

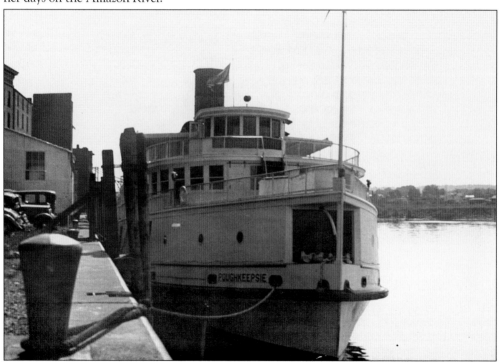

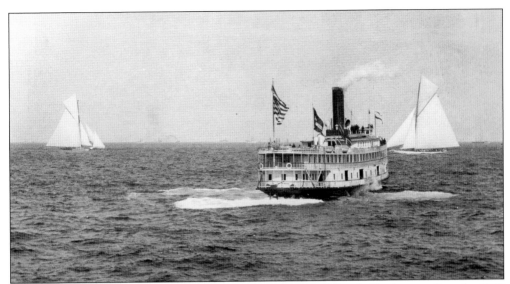

This rare view shows the *Homer Ramsdell* in the Atlantic off Sandy Hook, attending the 1899 America's Cup races between the *Shamrock* and *Rainbow*. In 1929, the Central-Hudson Line filed for bankruptcy and operation was taken over jointly by the Night Line and the Day Line. Newburgh service was dropped, and the *Newburgh* and *Homer Ramsdell* were sold for excursion use in Boston, renamed *Nantasket* and *Allerton*, respectively.

The *Benjamin B. Odell* is seen approaching the landing at Cornwall on a daylight excursion. After being purchased by Samuel Rosoff in 1935, she continued running between New York and Albany through the winter of 1935–1936. The service was given up before the end of 1936, and the steamer was laid up at Marlboro. On February 22, 1937, she was destroyed by fire.

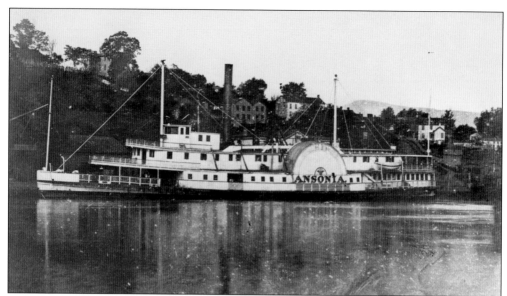

One of the villages that had its own steamboat line was Saugerties. In 1865, the steamer *Ansonia* was placed in overnight service to New York. Built in 1848 to operate between New York and Connecticut, she came to the Hudson in 1860 to run to Fishkill Landing. In 1865, the boat was sold to the recently organized New York & Saugerties Transportation Company.

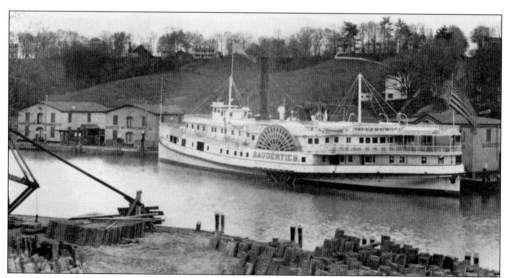

Another line was formed to compete with the *Ansonia*. It was incorporated in 1889 as the Saugerties & New York Steamboat Company and had purchased the steamer *Shenandoah*, built in 1882. She was renamed *Saugerties* and is shown at her Saugerties wharf. The two buildings to the left are still standing today, and Saugerties & New York Steamboat Company can still be seen in faded lettering.

In 1891, the Saugerties & New York Steamboat Company purchased the *Ansonia* and all rights of the older line. In the years ahead, Saugerties Evening Line would become the trade name for the company. This rare view shows the *Saugerties* departing her New York wharf, heading into the late afternoon sun for the trip upriver.

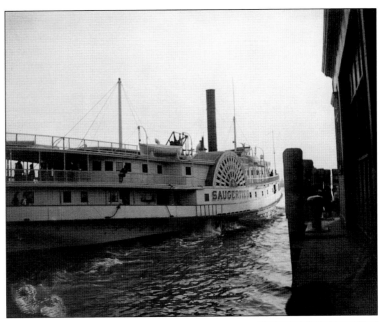

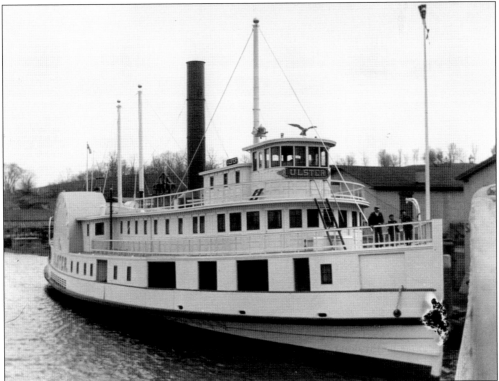

During the winter of 1891–1892, the *Ansonia* was lengthened and completely rebuilt. The changes were so extensive that she was enrolled as a new vessel named *Ulster*. In this photograph, the steamer is shown at the company wharf on the south side of Esopus Creek in Saugerties. There is a handsome gold leaf eagle on the pilothouse roof, a typical decoration on American steamboats of the period.

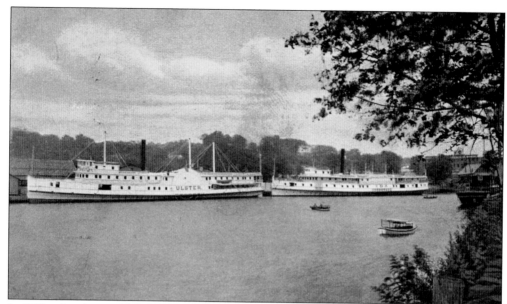

In 1903, a fire destroyed the *Saugerties* at her wharf. The remains were raised and beached on the flats just north of the Saugerties lighthouse. A replacement vessel was needed, so the company purchased the steamer *Ida* from Chesapeake Bay. She was built in 1881 and had a 190-foot iron hull. This postcard shows the *Ulster* (left) and the *Ida* at Saugerties.

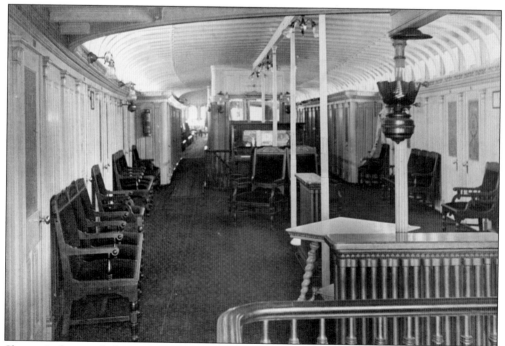

Shown is the top deck stateroom hall on the *Ida*. Although much smaller and less grand than the interiors of the big Albany and Troy steamers, it was still very comfortable and welcoming. Note the large steam heat radiator and the piano in the middle distance. It appears that she had both electric lights and oil lamps.

At the end of the 1920 season, the *Ulster* (former *Ansonia*) was once again extensively rebuilt, including the removal of her large rounded paddle boxes. At that time, the vessel was renamed *Robert A. Snyder*. This photograph captures her on a summer morning on Esopus Creek at Saugerties. She had recently landed after an overnight trip up from New York.

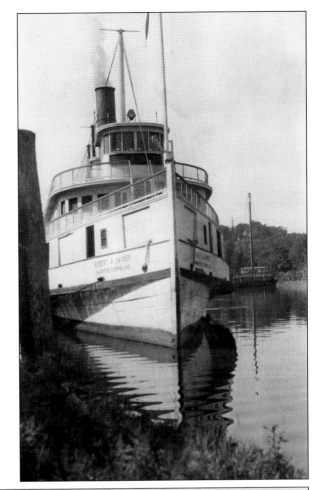

By 1932, both steamers of the line had been retired and lay at Saugerties. During the winter of 1935–1936, the ice holed the *Robert A Snyder's* wooden hull, and she settled to the bottom. She is seen here aft of the decrepit *Ida*. Later, in 1936, both steamers were auctioned off for scrap. (Photograph by William H. Ewen Sr.; author's collection.)

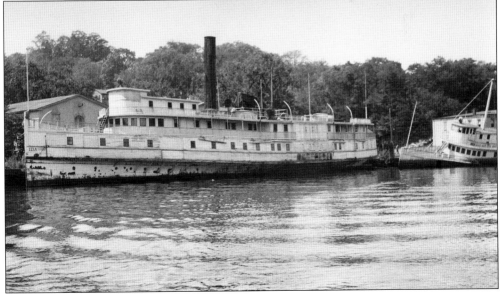

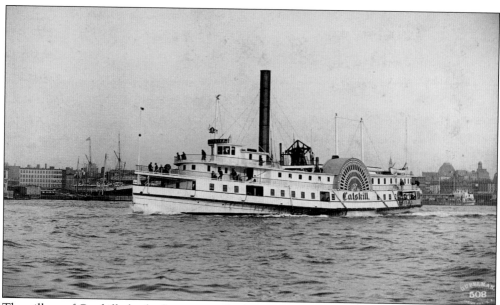

The village of Catskill also had its own night line. The steamer *Catskill* was built as the *Escort* in 1863 for owners who wanted vessels to charter to the Quartermaster Corps for profit. The steamer ran on several different routes until 1873, when she was purchased by the New York, Catskill, and Athens Steamboat Company (Catskill Evening Line). She was renamed *Catskill* in 1883. (Photograph by Gubelman; author's collection.)

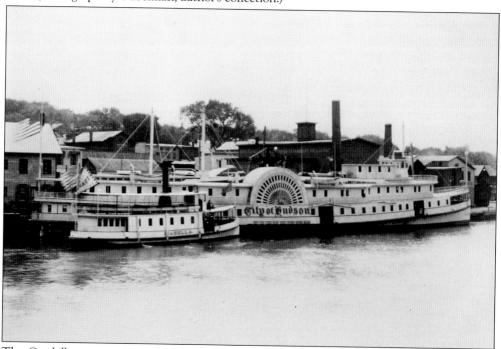

The *Catskill* ran opposite an older steamer, the *Walter Brett*. In 1897, the *Catskill* was sunk in a collision in New York harbor. The following year, after being raised, she was rebuilt and lengthened. At that time, the name was changed to *City of Hudson*. She is shown above in the creek at Catskill. Laid up in 1910, she was scrapped in 1911.

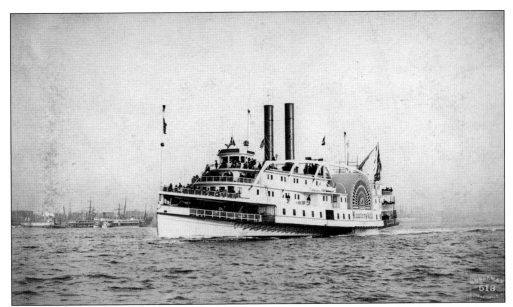

In 1880, the Catskill Evening Line built the *City of Catskill*. Her life was brief as she burned during winter lay-up in 1883. In 1882, the line had built the larger *Kaaterskill*, shown above, as a running mate for the *City of Catskill*. Instead, she ran opposite the older *Escort* and *Walter Brett*. In 1911, the vessel was chartered to another line and made her last trip in December 1913.

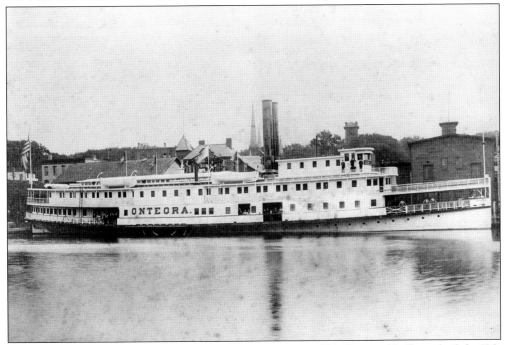

The *Onteora* was delivered to the Catskill Evening Line in 1898. Her steel hull was built by T.S. Marvel at Newburgh. She ran opposite the *Kaaterskill* and, later, the *Clermont*. In 1918, the Catskill Evening Line went into receivership, and the passenger business dropped. In 1919, the *Onteora* was sold to the commissioners of the Palisades Park, and in 1936, she burned while in winter lay-up at Bear Mountain.

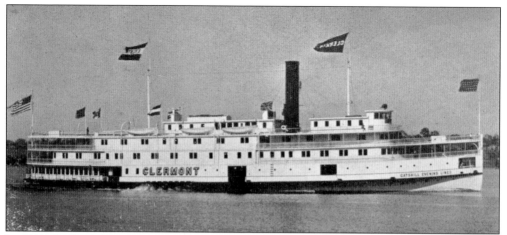

In 1911, the line's largest steamer, the *Clermont*, was built at Newburgh. She was probably the last walking beam engine steamboat built for the Hudson River. Like the *Onteora*, her time as a night boat ended when the Catskill Evening Line went into receivership. The steamer was sold to the commissioners of the Palisades Park in 1919 and was converted to an excursion boat for service to Bear Mountain.

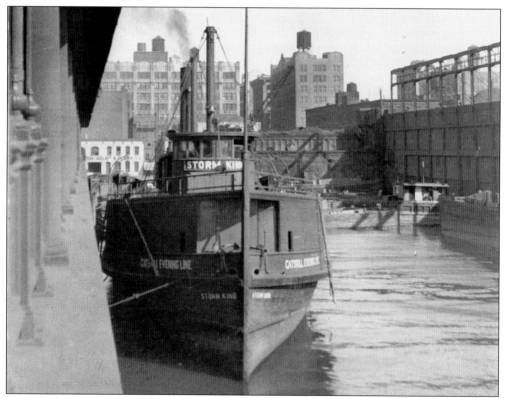

In 1911, the Catskill Evening Line had the wooden hull freight boat *Storm King* built. In 1913, the line purchased an older boat, the *Reserve*. The company began using freight steamers to free space for automobiles on the passenger steamers. While the line dropped passenger service in 1918, it continued as a freight carrier using these steamers. Here, the *Storm King* is unloading at a New York wharf.

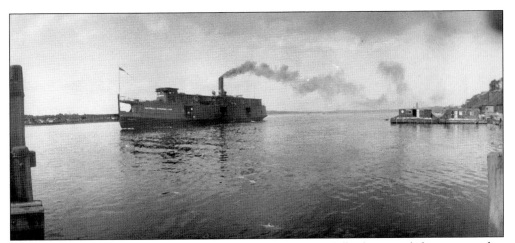

The last steamer built for the line was the steel-hulled *Catskill*. She joined the two wooden freighters in 1923 and was sold six years later. The *Storm King* made her last trip in 1932. She and the *Reserve* were later abandoned. The *Catskill* continued in other services, ending her career in the 1960s as a Long Island Sound car ferry. (Courtesy of the Ringwald Collection, Hudson River Maritime Museum.)

There were low fare lines that ran in opposition to the established night boats to Albany. These steamers were usually aged. This shows the *Greenport* of the Capitol City Line. She was built in 1866 as the *Star of the East* for service between Boston and Maine and later renamed *Sagadahoc*. Running between New York and Long Island, the steamer was renamed *Greenport*. She came to the Hudson in 1914.

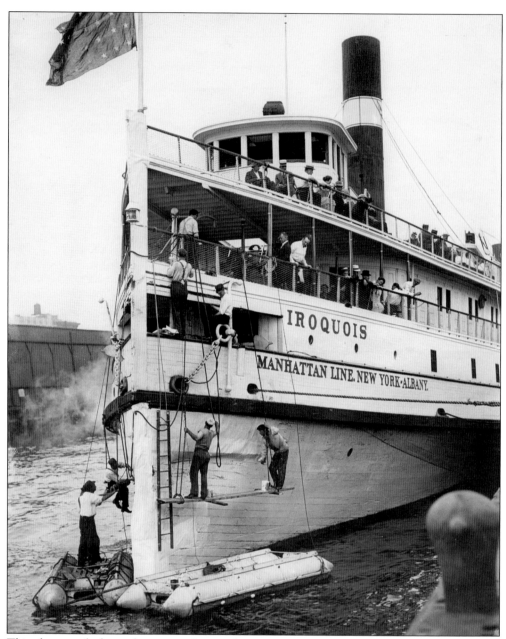

This photograph shows the steamer *Iroquois* having some stopgap repairs made on her bow with canvas and paint. This would hardly be acceptable in the modern days of strict regulations. The damage may have been the result of running into the stern of the anchored *Berkshire* in heavy fog. The *Iroquois* was built as the *Kennebec* in 1889 for service between Boston and Maine and came to the Hudson in 1911 to run on the low fare Manhattan Line. The following year, her name was changed to *Iroquois*. The boat was laid up from 1914 to 1918 and was then sold to the Navy and operated as a freight boat on Chesapeake Bay. She was later abandoned in Virginia. Her running mate on the line was another former Maine coast steamer, the *Penobscot*, built in 1882. This steamer came to the Hudson the same year as the *Kennebec*, and in 1912, her name was changed to *Mohawk*. The *Mohawk* ran through the 1915 season.

Three

HUDSON RIVER DAY LINE

With an international reputation, the Hudson River Day Line was one of the most famous of all American steamboat companies. The line's steamers were fast, comfortable, well maintained, and manned by capable crews.

In the early 1800s, Alfred Van Santvoord followed his father into the steam towing business. His interests, however, went beyond towing. In 1855, he purchased the 149-foot side-wheeler *Alida* and placed her in New York–Albany passenger service. Only two years later, the *Alida* was converted to a towboat. Van Santvoord continued his interests in passenger vessels and was in and out of several partnerships involving some of the finer steamboats of the time. In 1863, with two partners, he purchased the graceful steamer *Daniel Drew*. Not long after, they also purchased the competing steamer *Armenia*, giving Van Santvoord control of New York–Albany daylight service. The company at that time had no official name. It was referred to as the New York and Albany Day Line, among other things. Years later, it would officially become the Hudson River Day Line.

When Alfred Van Santvoord died in 1901, his son-in-law Eben Olcott became president. He oversaw the greatest expansion of the fleet and built the Day Line into one of the finest companies of its kind in the world. Upon his death in 1929, his son Alfred Van Santvoord Olcott became president and was the last of the family to control the line. In 1948, due mostly to the competition from automobiles, the company went out of business. It seemed as though the steamers would disappear from the river, but the line was purchased by a group headed by George Sanders. Albany service was eliminated, and Poughkeepsie became the northernmost landing. The largest and oldest of the four remaining vessels, the *Hendrick Hudson*, was retired. At the end of the 1962 season, the line was sold to the Circle Line. While under that ownership, the last Hudson River side-wheel steamboat made her final voyage.

This chapter will look at some of the steamers and people of the Day Line.

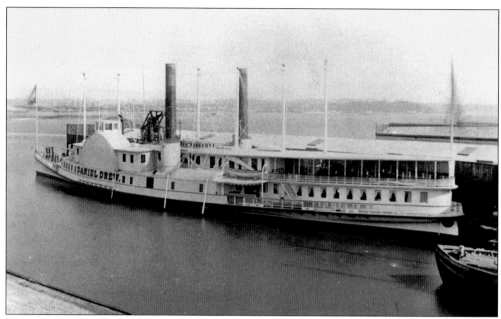

The graceful *Daniel Drew* was built in 1860 in New York by Thomas Collyer. Her engine came out of an earlier steamer, the *Titan,* and she was an exceptionally fast vessel. The *Daniel Drew* was owned by Collyer and several other men until September 1863, when she was sold to Alfred Van Santvoord and his partners. A fire that started on shore destroyed the steamer at Kingston Point in 1886.

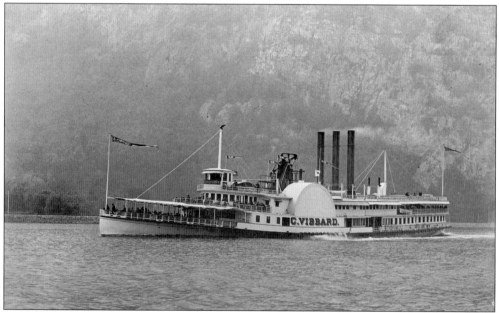

Van Santvoord had the *Chauncey Vibbard* built in 1864 as a running mate to the *Daniel Drew.* Originally, she had her boilers on the guards, but in 1880 was rebuilt with boilers placed in the hull. After that, she had three stacks abreast, as shown here. She became a spare boat in 1887. In 1895, the vessel was sold for service out of Philadelphia. (Photograph by Gubelman; author's collection.)

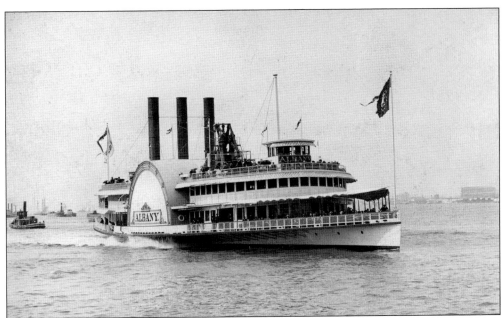

In 1880, the Day Line built the steamer *Albany*. She was only the second steamer on the river with an iron hull. There was no longer a need for a massive hog frame. She was also the first originally built with three smokestacks abreast. With radial paddle wheels, she had the large paddle boxes, but they lacked the fan decorations that were so common. Her second deck was later extended to the bow and, in the fall of 1882, the vessel had a major rebuilding. She was lengthened 30 feet and her radial wheels replaced with feathering paddle wheels. The most obvious change in appearance, as shown below, is the absence of the large paddle boxes. The *Albany*'s smaller feathering wheels were now concealed behind dummy windows. (Above, photograph by Gubelman, author's collection; below, Roger W. Mabie collection, courtesy of the Mabie family.)

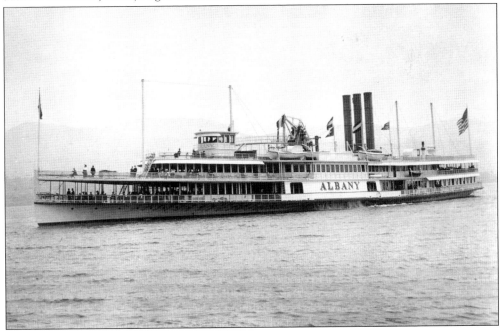

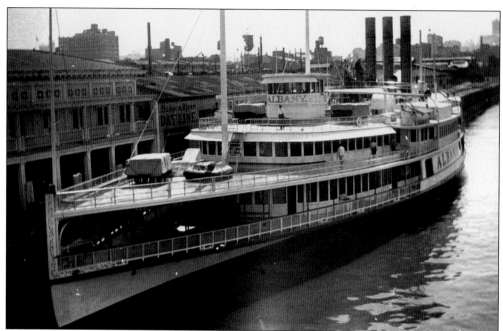

The *Albany* was built to replace the *Daniel Drew* and in her early years ran opposite the *Chauncey Vibbard*. With the advent of newer steamers, the *Albany* was eventually taken off the Albany run and put into service to Poughkeepsie. Over the years, she was used on a variety of runs, including replacing the *Mary Powell* in Rondout–New York service. Finally, in 1935, the steamer was sold and renamed *Potomac* for excursions out of Washington, DC. She ran on the Potomac River until 1948. The boat's walking beam is now preserved at the Mariner's Museum in Newport News, Virginia, and her hull was converted to a barge. In the image above, she is laying at the Day Line's Pier 81 in New York. Below, the vessel is heading south on a smooth Newburgh Bay. (Below, courtesy of William G. Muller.)

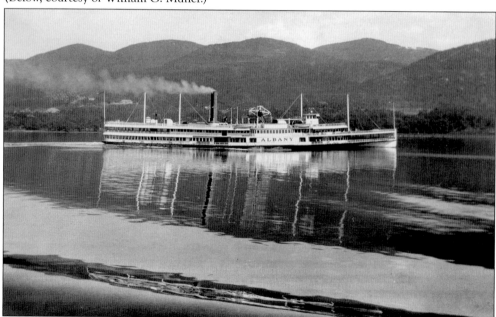

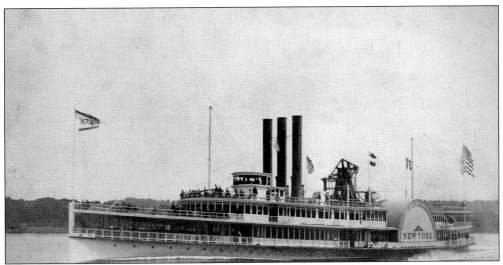

In 1887, after the loss of the *Daniel Drew*, the company built the *New York* as a running mate to the *Albany*. The two steamers were similar and made a fine matched pair. This is a spirited view of the *New York* at speed, probably when new. The frames are in place, but the visor over the pilothouse windows and the deck awnings have not yet been installed.

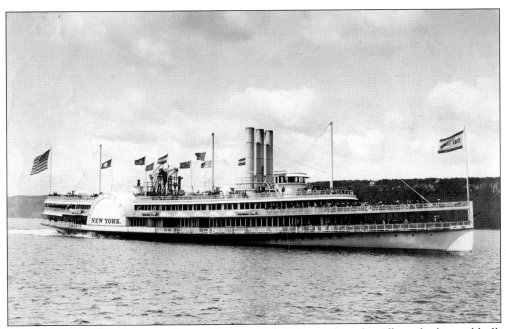

The *New York* differed in several ways. She was slightly larger than the *Albany*, had a steel hull, and, most noticeably, her smokestacks were forward of the engine and paddle wheels. The steamer was also built with feathering paddle wheels but was unusual in that she still had the traditional large paddle boxes. In 1897–1898, as shown here, 34 feet was added to the length between engine and boilers.

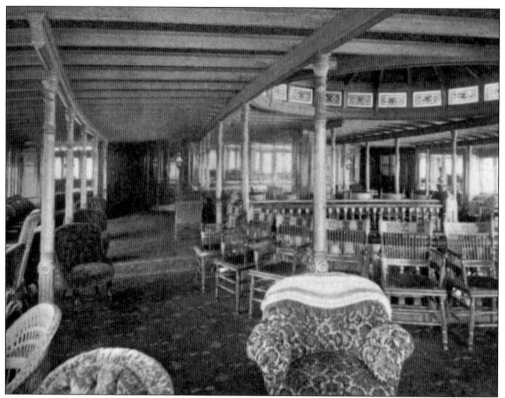

The interiors of the larger steamboats often reflected the design and fittings of the finer homes and hotels of the period. This view looks aft in the comfortable forward observation saloon of the *New York*. It includes rich carpeting, plush furniture, and a domed clerestory with stained glass windows.

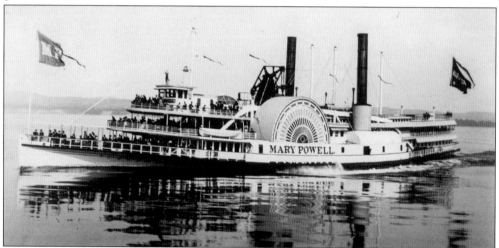

This classic photograph shows the most famous of all Hudson River steamboats. The *Mary Powell* was built in 1861 for Rondout–New York service. The top priority of owner and captain Absalom Anderson was passenger comfort and safety. During her long career, she was known for grace, speed, and consistently being on time. She was referred to as "The Queen of the Hudson." (Photograph by Loeffler; author's collection.)

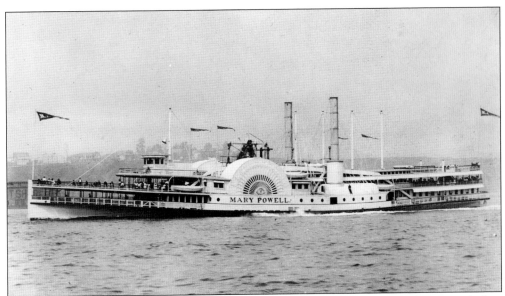

Over the years, the *Mary Powell* was modified and changed owners a number of times, including Captain Anderson's son Eltinge in 1884. He later became captain. Finally, in 1902, the Day Line gained control for the second time. Among other changes, they extended the second deck to the bow and painted the stacks buff, as shown here.

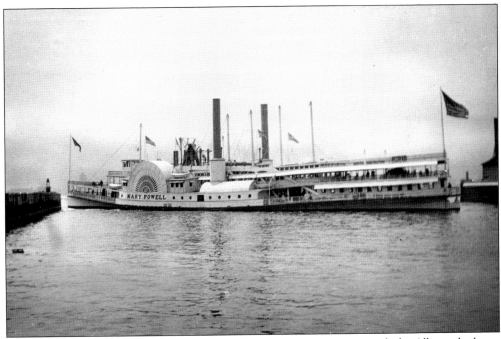

In her last years, the *Mary Powell* shared the Rondout–New York service with the *Albany*, the latter handling it in July and August. During those months, the *Powell* was made available for charters. Her last active year was 1917. The *Powell* was laid up for several years in Rondout Creek and finally scrapped. This view shows the steamer backing into her New York slip late in her career.

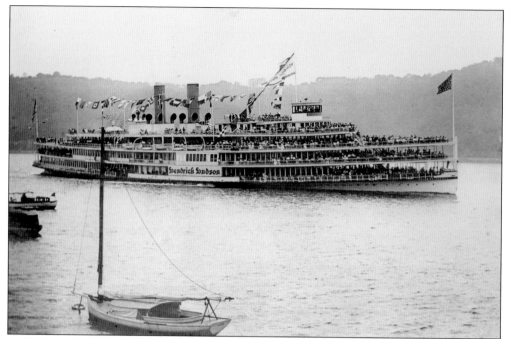

In 1906, the Day Line had the *Hendrick Hudson* built at Newburgh. She was advanced in design and set the tone for many future steamers on the river. She had no masts and was the first on the Hudson with an inclined engine. In this view, the steamer is approaching Poughkeepsie on her first trip. The awnings and the curves on either side of the name have not yet been installed.

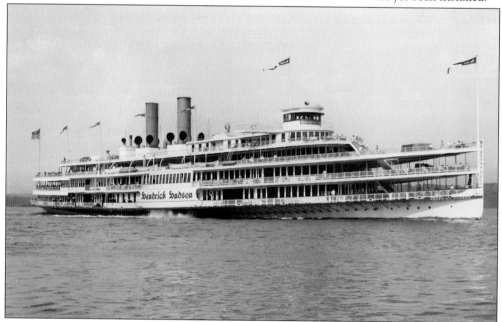

The *Hendrick Hudson* was a magnificent passenger steamer. Naval architects have called her one of the finest day passenger steamers ever built. She was designed by Frank E. Kirby and J.W. Millard. The general contractor was the T.S. Marvel Shipyard, and the engines were built by the famous W&A Fletcher Company. This image shows her running slow, approaching a landing.

This morning view from the George Washington Bridge shows the *Hendrick Hudson* steaming upriver with a capacity crowd. In addition to a licensed capacity of 5,000 passengers, she was quite fast. On her trial trip, she did about 24 miles per hour. There was so much interest in the new steamer that thousands lined the shore to see her pass on her first trip. (Photograph by Alexander P. Olcott; author's collection.)

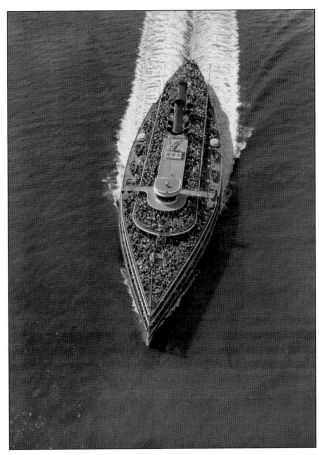

The *Hendrick Hudson* is running at full speed in the upper river on an overcast day. The hull design of these steamers allowed them to cut the water like a knife. Note the long, clean bow wave. A plume of steam is rising from the whistle as she salutes the steamer the photograph was taken from. (Photograph by Donald C. Ringwald; courtesy of the Hudson River Maritime Museum.)

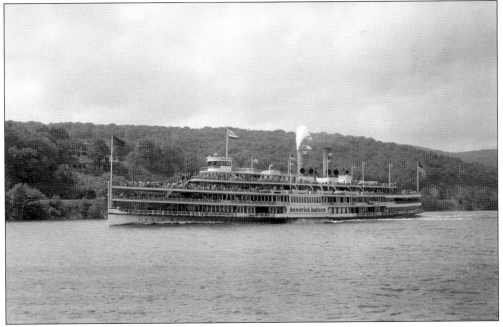

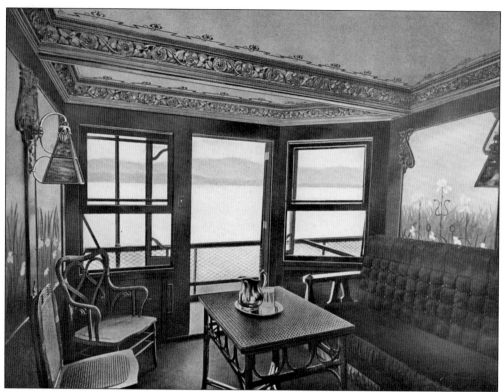

Most of the Day Line steamers had private day parlors that could be rented for the duration of a trip. These provided a place for families or small groups to be by themselves. Each parlor had room service and most had a private deck, as seen here on the *Hendrick Hudson*. The pyramid-shaped wall lamps were created for the steamer by the Tiffany Company of New York.

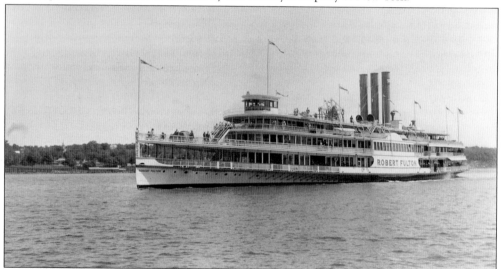

In 1908, the *New York* burned at Newburgh while laid up after the season. The following year was the great Hudson-Fulton Celebration, and the company needed a replacement quickly. By utilizing part of the *New York's* engine, including the walking beam and boilers, the new *Robert Fulton* was built in record time. She is shown approaching the landing at Kingston Point.

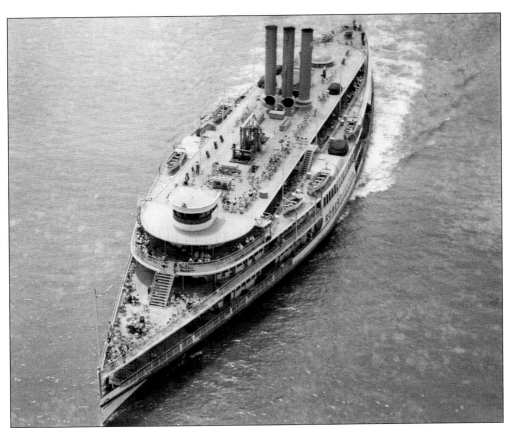

It took only four and a half months from the laying of the keel until the *Robert Fulton's* first trip in May 1909. The Day Line had hoped to build a steamer the size of the *Hendrick Hudson* but there was not time. With a walking beam engine and three stacks abreast, the steamer had some external features of the 1880s rather than the early 20th century. (Photograph by and courtesy of William G. Muller.)

Although the *Robert Fulton* was built in a short period of time, there was great attention to detail. Visible in this close-up of the bow are a deeply carved, gold leaf stem and gold leaf name cut into the guards. She was very comfortably appointed and, over her 45 years of service, was one of the most popular steamers on the river. (Photograph by William K. Covell; author's collection.)

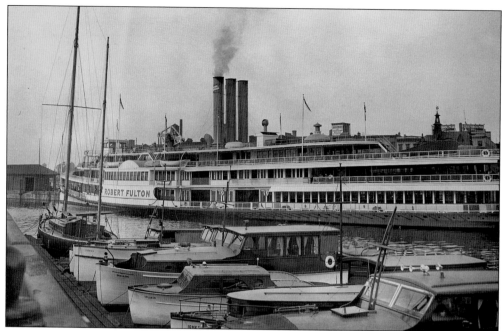

In the basin at the Day Line wharf in Albany, the *Robert Fulton* is getting ready to receive passengers for the trip down river. In the foreground are motorboats moored at the Albany Yacht Club. This area, once called Steamboat Square, is now filled in and covered by highways. (Photograph by William K. Covell; author's collection.)

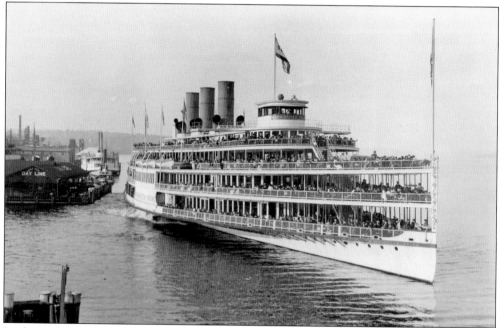

In the early years of the 20th century, passenger traffic continued to grow, and the Day Line needed a suitable running mate for the *Hendrick Hudson*. In 1913, the company built the 400-foot side-wheeler, *Washington Irving*. She had a licensed capacity of 6,000, the largest of any ship in the world at the time. In this view, she is departing Newburgh, heading down river.

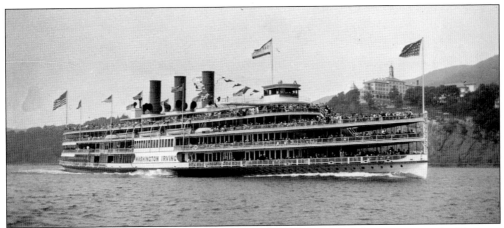

The *Washington Irving* was probably the fastest regularly scheduled ship to run on the Hudson. She is shown here, at speed, passing Lady Cliff College just south of West Point. These buildings and grounds are now part of the US Military Academy. The *Washington Irving* had three smokestacks to visually balance her great length, but the forward one was a dummy. (Photograph by Arthur Helmke; author's collection.)

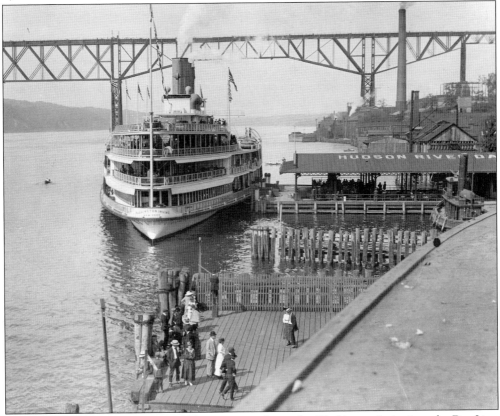

In this interesting view of the Poughkeepsie waterfront, the *Washington Irving* is at the Day Line wharf, facing north. Her hull had an innovative cruiser stern, which helped to increase speed. In the background is the Poughkeepsie Railroad Bridge. In 2009, this bridge was reopened as a pedestrian pathway.

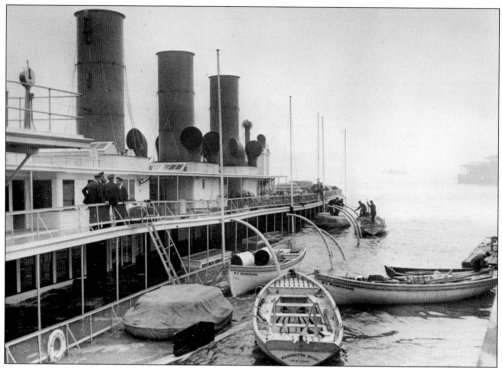

In June 1926, disaster struck. The *Washington Irving* had just departed Debrosses Street in New York on a hazy morning. She was hit by a steel oil barge alongside a tug, and her hull ruptured. Captain Deming brought the ship into shallow water, where she settled to the bottom. The wavy decks indicate that her hull was twisted. The steamer was a total loss. Both captains were exonerated of blame.

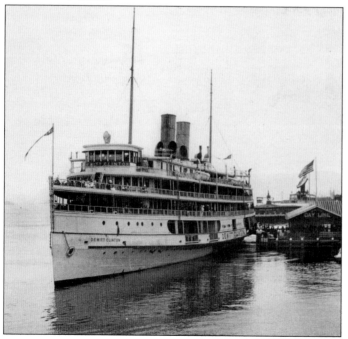

In 1920, the Day Line purchased a 320-foot twin-screw steamer. She was built as the *Manhattan* in 1913, for overnight service between Providence and New York. She never operated on that run and was taken by the government for World War I and renamed *Nopatin*. After purchasing the vessel, the Day Line extensively rebuilt and renamed her *Dewitt Clinton*. She is shown at Newburgh. (Courtesy of the Ringwald Collection, Hudson River Maritime Museum.)

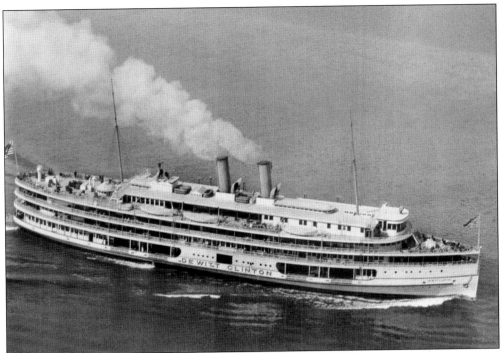

The company needed a large capacity steamer for the increasingly popular New York–Poughkeepsie one-day round-trip. Rather than building a new vessel, purchasing the seven-year-old ship made good sense. She was suitable and available. As the *Dewitt Clinton*, the steamer did not operate above Poughkeepsie because she was too deep for the depth of the upper river at that time.

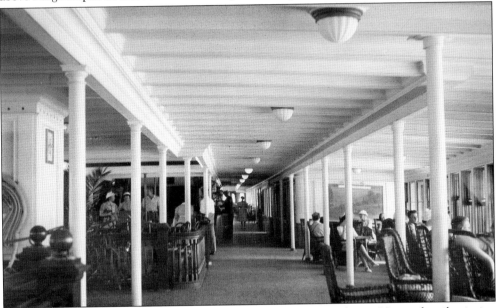

This is the comfortable interior of the saloon deck on the *Dewitt Clinton*. Notice the oil painting on the bulkhead to the right. The Day Line had a tradition of commissioning well-known painters to create murals depicting the river and scenes from the life of the ship's namesake. (Courtesy of William G. Muller.)

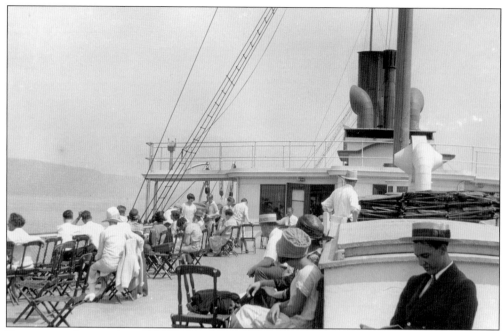

Passengers relax on the top, or hurricane, deck of the *Dewitt Clinton*, headed upriver off the Palisades. Notice the folding carpet seat chairs. They folded flat and stacked easily for storage, as can be seen in the pile to the right. On the Day Line, the ship's name was usually cut into the base of the backrest. (Courtesy of William G. Muller.)

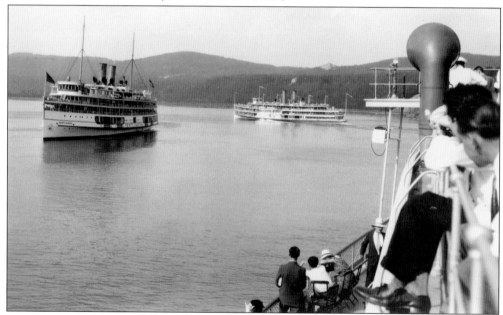

The *Dewitt Clinton* is waiting as the *Peter Stuyvesant* (right) leaves West Point. The *Alexander Hamilton* steams by in the background. The *Clinton* was laid up in 1930 but reactivated in 1939 for the world's fair. In 1942, she was again taken for war service and rebuilt into an ocean steamer named *Frederick C. Johnson*. The steamer last operated in the Mediterranean under the name *Galihah*.

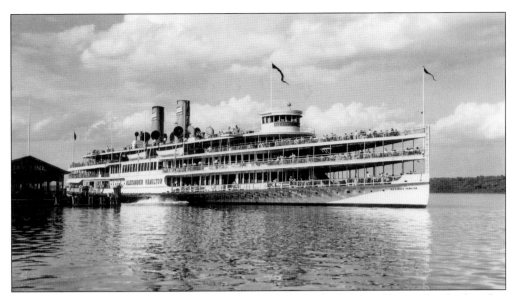

In the *Washington Irving* and *Hendrick Hudson*, the company had a pair of large side-wheelers that were well matched. They now planned a new steamer that would be a mate to the smaller *Robert Fulton*. The 338.6-foot *Alexander Hamilton* entered service on May 29, 1924, and would ultimately be the last side-wheeler on the Hudson River. She is shown landing at Newburgh.

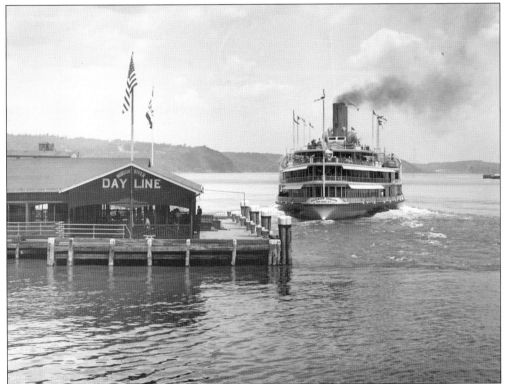

The *Alexander Hamilton* had a cruiser-style stern like the *Washington Irving*. Her engine was an inclined triple expansion, and she was the last side-wheeler built for the Day Line. She is just pulling away from the wharf in Newburgh, heading north. The next landing will be Poughkeepsie.

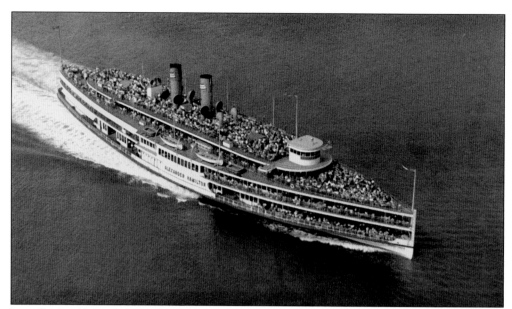

Initially the *Alexander Hamilton* had a licensed capacity of 4,050 passengers. In later years, it was reduced to 3,675. She was the first oil-burning steamer built by the Day Line. Others were later converted from coal to oil. This view was taken from the George Washington Bridge on July 4, 1955. (Photograph by and courtesy of William G. Muller.)

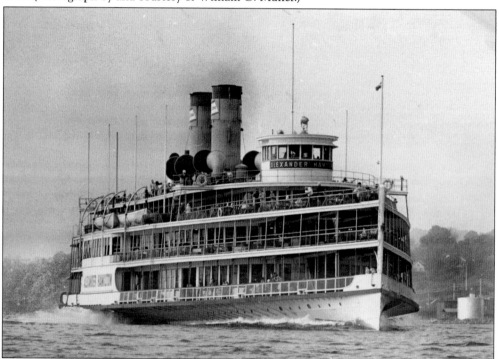

In this late-afternoon image from the 1960s, the *Alexander Hamilton* is heading south off Dobbs Ferry. In her later years, the tops of the smokestacks were painted black. Unfortunately, the steamer was not maintained as elegantly as she had been in her earlier years, but it was a treat to still have her in service on the river. (Photograph by author.)

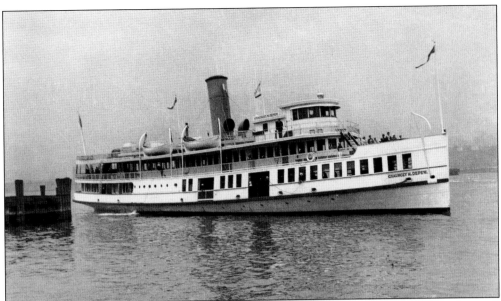

Charter business was becoming increasingly important. In 1925, the Day Line purchased a small but handsome steamer named *Rangeley*. She was built in 1913 by the Maine Central Railroad for service on the Maine coast. After reconditioning and reequipping, she was renamed *Chauncey M. Depew* and began 15 years of service on the Day Line.

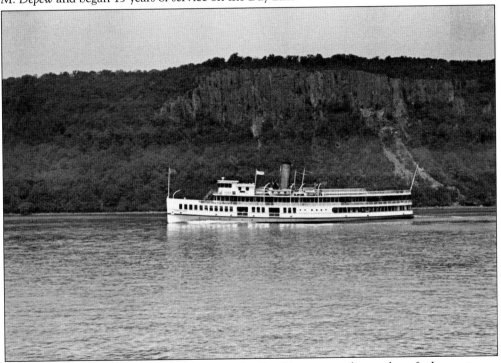

In addition to the New York–Albany service, the Day Line operated a number of other routes on the river. Besides charter and excursion work, the *Chauncey M. Depew* ran one-day round-trips from Poughkeepsie to New York. This view shows her heading down river in the morning, past the Palisades.

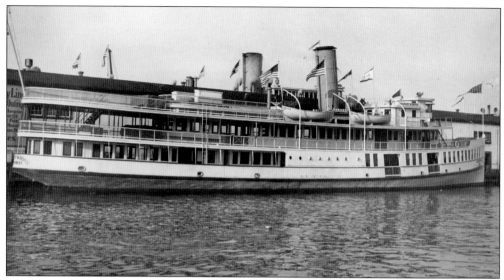

On a summer morning at the Day Line's Forty-second Street terminal, the *Chauncey M. Depew* and her fleet mates are beginning to board the day's passengers. Because the *Depew* was so much smaller than the other steamers, the company dubbed her the "Day Line Yacht." Her last active service was in Bermuda, and she ended her days as a restaurant in New Jersey. (Photograph by William K. Covell; author's collection.)

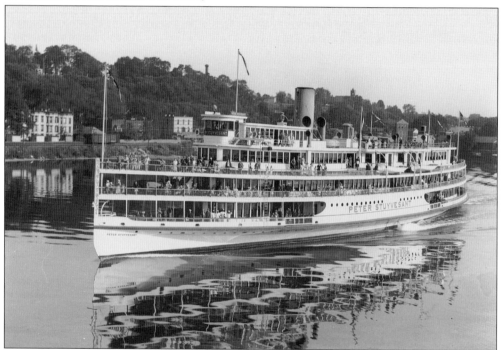

The Day Line was unable to build a large replacement for the *Washington Irving*. Charter business was growing, so in 1927, the company built a smaller, single-screw steamer named *Peter Stuyvesant*. In this view, often used in company publications, the steamer is off Castleton-on-Hudson in 1937. She had many features, including a large dance deck that appealed to groups interested in chartering. (Photograph by Alexander P. Olcott; author's collection.)

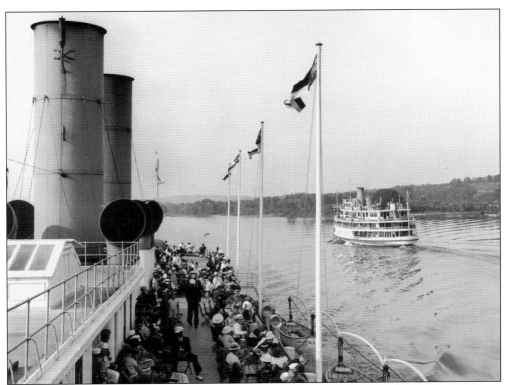

The *Peter Stuyvesant* and *Hendrick Hudson* are running slow as they pass each other in the narrow upper river. The photograph was taken from the bridge wing of the *Hudson*, looking aft over the hurricane deck. The absence of stack markings indicate that it is before 1939, the year the house flag was painted on the smokestacks of all the steamers.

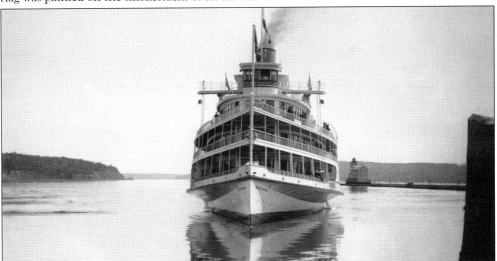

The *Peter Stuyvesant* is approaching the Kingston Point landing in 1935. She was the first propeller steamboat built by the Day Line and also the last steamer the company ever built. She was laid up at the end of the 1962 season. After several years, she was restored as a restaurant in Boston and ultimately sank in the blizzard of 1978. (Photograph by Roger W. Mabie; courtesy of the Mabie family.)

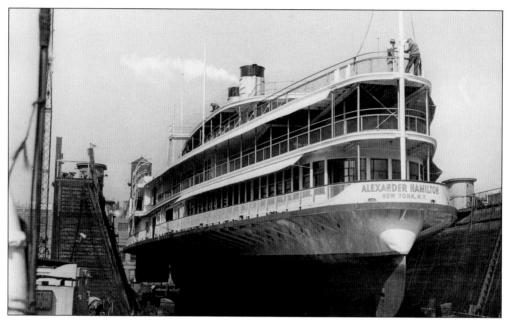

Spring was a busy season for those involved in operating steamboats. The Day Line was no exception. After the long winter lay-up, there was much to do to get ready for the summer. The vessels would go into the shipyard for hull, engine, and other heavy work. This view shows the *Alexander Hamilton* later in her career at the Todd Shipyard in Hoboken. (Photograph by and courtesy of William G. Muller.)

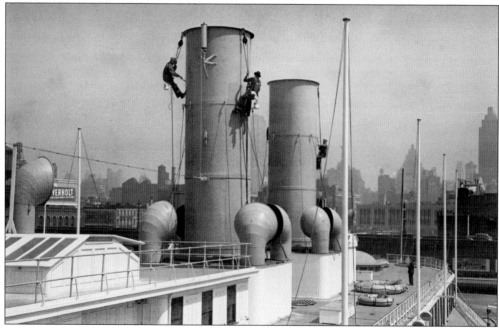

Most of the superstructure painting was done when the steamer returned to the company wharf. Here, in the spring of 1938, workers are painting the smokestacks of the *Hendrick Hudson* at the Day Line's Forty-second Street pier. Carpenters would also be at work repairing or replacing woodwork, as needed.

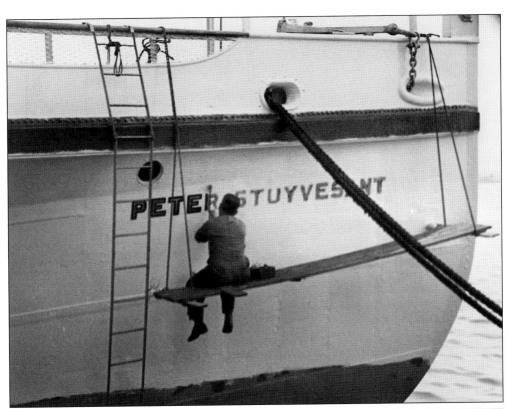

An example of the attention to detail during the family ownership of the Day Line is this unidentified sign painter at the bow of the *Peter Stuyvesant* in the spring of 1938. He has lettered the ship's name in gold leaf and is now in the process of carefully outlining the letters in black.

Most of the Day Line personnel grew up along the banks of the Hudson and loved the river from childhood. The company was proud of its crews. This view on the main deck of the *Albany* shows some of the officers. Seated second from right is the chief engineer, Philip St. Pierre. This was taken prior to the steamer's 1882 rebuilding.

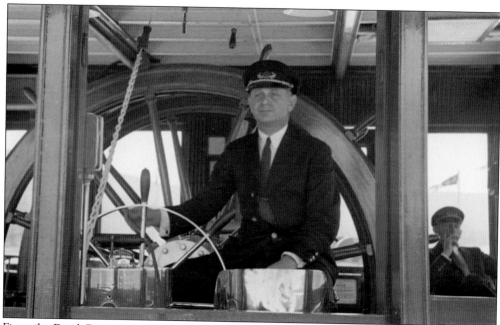

First pilot Frank Brown is at the wheel of the *Hendrick Hudson*. The wheel he is using is connected to a steam steering engine. If a problem developed with this engine, the large wheels in the background would be engaged. Called hand gear, they were connected directly to the rudder and would require four burly deck hands to steer. Captain Brown was later the last master of the steamer.

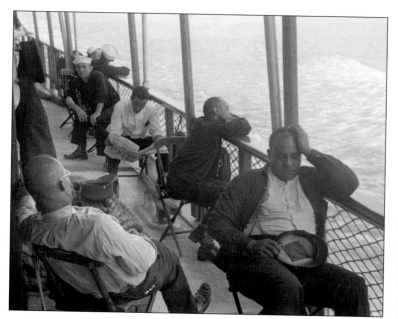

Deckhands and hall men (porters) relax during downtime on the main deck of the *Hendrick Hudson*. From the captain to chefs and waiters, all of the crewmen on the Day Line steamers had uniforms that denoted their department. This area, known as the quarterdeck, was not open to passengers.

Capt. Alonzo Sickles is standing at the gangway of the *Hendrick Hudson* with his hand on a bell pull. As a steamer was making a landing, the captain would go down to the main deck. Using bell signals, he would let the pilot know when the gangway was lined up properly with the dock. This, of course, was before the days of handheld radios.

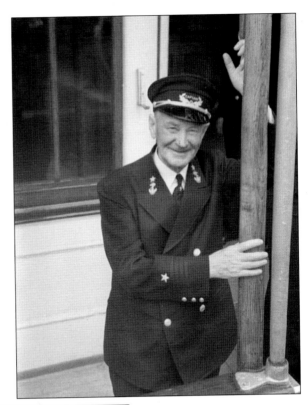

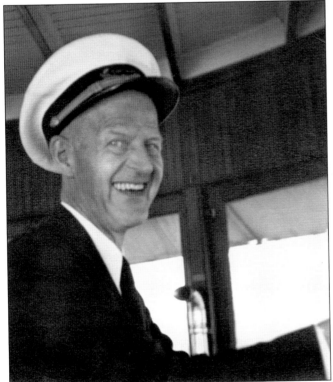

Capt. George Reitnauer is seen in the pilothouse of the *Robert Fulton* on September 4, 1951. The author has fond memories of this friendly man, especially since he allowed him to steer the steamer. (The captain stayed close.) That was the thrill of a lifetime for a young boy.

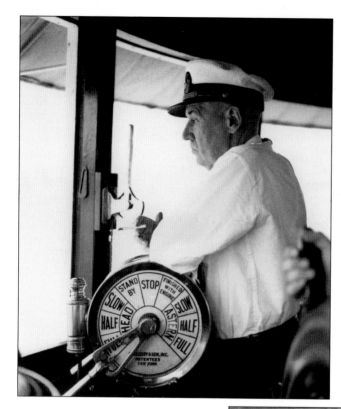

Pilot George Carroll of the *Alexander Hamilton* spent many years working on steamboats and had been one of the youngest masters on the Central-Hudson Line. He told how, while breaking a channel in the ice, the crew would throw old Christmas trees off each side as markers. On the return trip, they would steer between the trees, knowing the newly formed ice would be thinner. (Photography by author.)

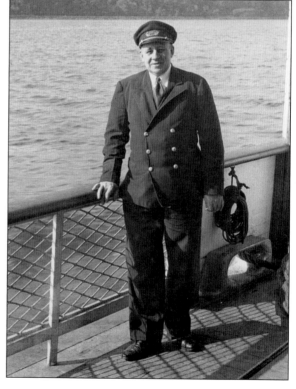

Many former passengers remember Elvoid Post, shown here in 1948. He became chief engineer of the *Alexander Hamilton* in 1947 and continued until the boat's last trip in 1971. Chief Post was always very welcoming to those interested in the steamers. In the last years, many people felt that he and the *Alexander Hamilton* kept each other going. (Photograph by William H. Ewen Sr.; author's collection.)

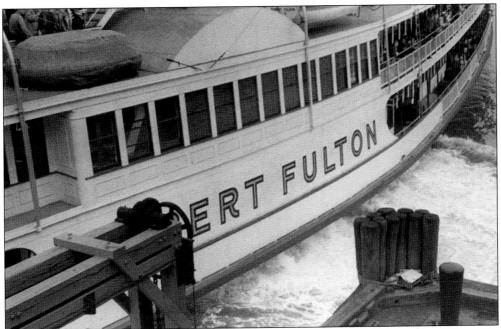

In this view, the *Robert Fulton* is reversing engines while landing at Yonkers. Foam from the paddle wheel is being pushed forward. Some officers knew the river and their vessels so well that they could use wind, tide, and only seven or eight revolutions in reverse to bring the steamer right to the pier. (Photograph by William H. Ewen Sr.; author's collection.)

Albany was one of the more difficult Day Line landings. The steamers had to back around a bulkhead at the Albany Yacht Club, using spring lines. This is looking aft from the bridge of the *Hendrick Hudson*. She will moor alongside the pier in the background. The small building with the tower to the right was the company's ticket office. Today, it is a restaurant.

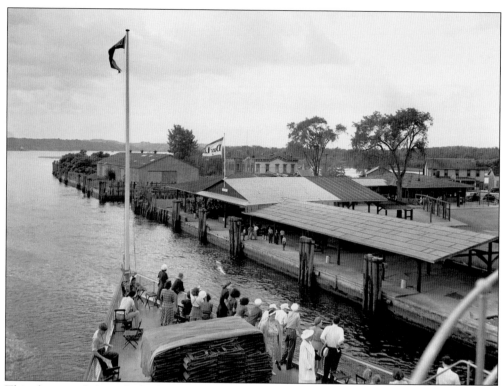

This photograph from the bridge deck of the *Robert Fulton* shows her approaching the landing at Catskill. The large building beyond the Day Line dock had been the freight shed of the Catskill Evening Line. The brick building to the right of that was the company office. All of these buildings still stand today, making this the most intact steamboat-era waterfront on the Hudson.

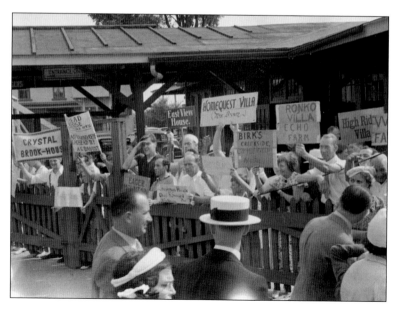

The view at left shows some of the runners from local hotels and inns who greeted passengers as they disembarked at Catskill. It was the mid-1930s and was still a time when the Day Line steamers were used as transportation to upriver resorts, as well as for day outings.

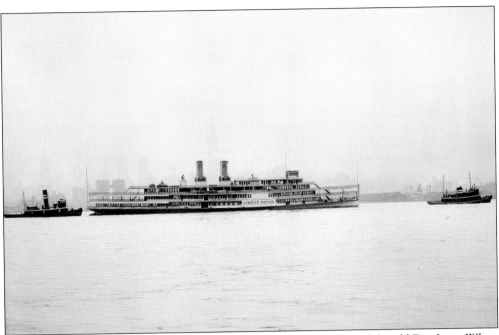

The *Hendrick Hudson's* last season in service was 1948, the last year of the old Day Line. When new owners took over in 1949, the steamer remained laid up at the Forty-second Street pier. After three years, she was finally sold for scrap. On an appropriately moody day, she was towed out of New York by McAllister tugs, bound for a Philadelphia scrap yard.

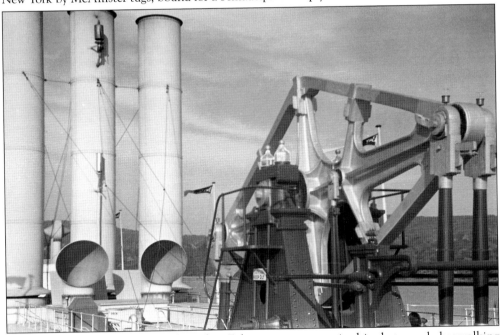

Although the hurricane deck of the *Robert Fulton* appears empty in this photograph, her walking beam, rocking up and down, was usually a source of fascination for passengers of all ages. The large whistle at the top of the center stack had originally been on the famous *Mary Powell*. The *Robert Fulton* made her last trip under steam on September 12, 1954.

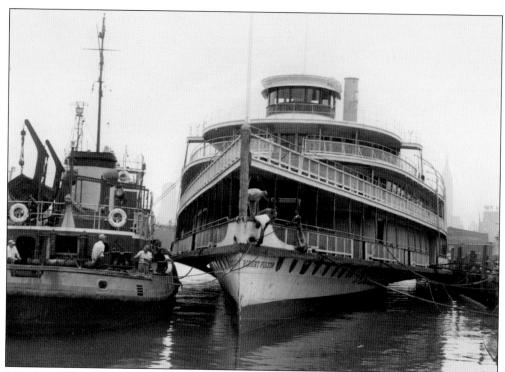

In 1956, the *Robert Fulton* was sold to be used as housing for woodcutters in the Bahamas. In this photograph, the tug *Peggy Sheridan* is preparing to tow her to Florida, where the machinery was removed. The portholes have been welded over, plywood is covering the main deck windows, and the paddle wheels have been cut off to eliminate drag during the long tow. (Photograph by author.)

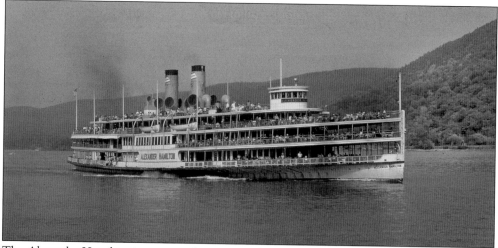

The *Alexander Hamilton* is running slow, approaching Bear Mountain at the end of her career. The following day, Labor Day 1971, was her last in service, ending 165 consecutive years of side-wheel steamboats on the Hudson. The steamer's last captain was Edward Grady, and the last pilot was Reginald Pinto. The *Alexander Hamilton* was donated to the South Street Seaport, but they sold her and she was ultimately sunk at a wharf in Atlantic Highlands, New Jersey. (Photograph by author.)

Four

EXCURSION BOATS

Regularly scheduled steamboats between landings on the Hudson had been an important means of transportation over the years. At the same time, day outings, or excursions, were very popular. The heyday of excursion boats on the river was roughly from the 1920s through the 1940s, although they lasted into the 1970s. After World War II, more and more people had their own automobiles and were less inclined to use a steamer as a primary means of transportation to locations up the river. Even before the Day Line dropped New York–Albany service after 1948, charters and excursions had become an important source of revenue for that company.

There was a large fleet of steamboats whose only business included excursions, moonlight sails, and charters. Some had previously been night boats or in other regularly scheduled services. Many others were New York harbor excursion steamers, as well as those from other locations along the East Coast. Most found occasional or consistent employment on the Hudson.

The most popular destination for excursions on the river was Bear Mountain, a beautiful wooded park owned by the Palisades Interstate Park Commission. The Day Line built a park of its own, called Indian Point. It is now the site of a nuclear power plant. Other destinations for excursions over the years included Fort Lee Park, Excelsior Park, Dudley's Grove, Croton Point Park, Hook Mountain Park, and many others farther upriver.

The automobile also eventually killed the excursion business. The number of steamers steadily diminished through the 1950s and 1960s until the last New York/Hudson River excursion steamboat was retired in the mid-1970s.

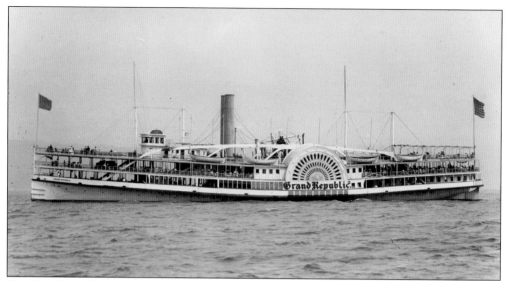

The *Grand Republic* was built in 1878 for service to Rockaway Beach and at the time was billed as the largest excursion steamer in the world. The McAllister Steamboat Company, later McAllister Navigation Company, was a major player in the excursion business on the lower Hudson. The company purchased the *Grand Republic* in 1917 to run to Bear Mountain.

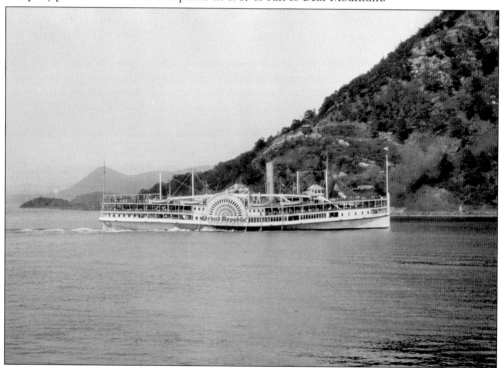

The *Grand Republic* has just left Bear Mountain in this image. A small crane is barely visible in the notch in the mountainside behind the steamer. Work was just beginning on the Bear Mountain Bridge. In 1924, the *Grand Republic* burned during lay-up with several other McAllister steamers and sank from the water pumped into her. The walking beam remained above the water well into the 1950s.

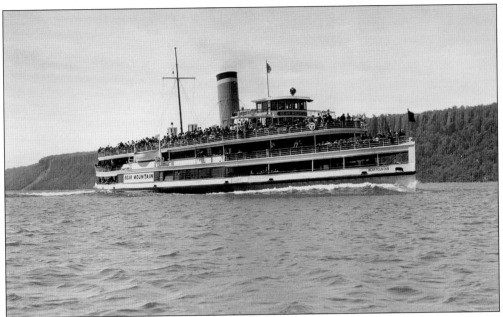

The *Bear Mountain* was built as the *William G. Payne* in 1902 for Bridgeport–New York service. McAllister purchased the boat in 1914 to run on the Hudson and renamed her *Highlander*. In 1924, she burned in the same fire that destroyed the *Grand Republic*. The *Highlander* was rebuilt with a modern appearance and renamed *Bear Mountain*. She is seen here passing Hastings-on-Hudson in 1940. (Photograph by William H. Ewen Sr.; author's collection.)

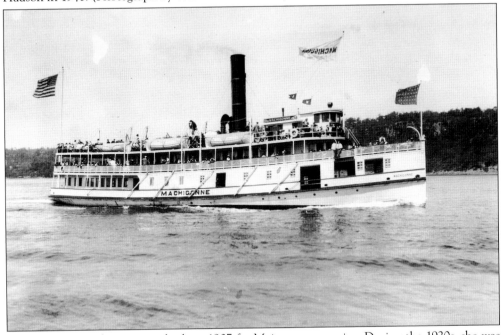

The Steamer *Machigonne* was built in 1907 for Maine coast service. During the 1920s, she was operating in New York waters as an excursion boat. In 1929, the vessel was purchased by McAllister to run to Hook Mountain Park. Within a month, the steamer was renamed *Hook Mountain*. She last ran to Block Island, as the diesel *Yankee*. She is still afloat as a private home in New Jersey.

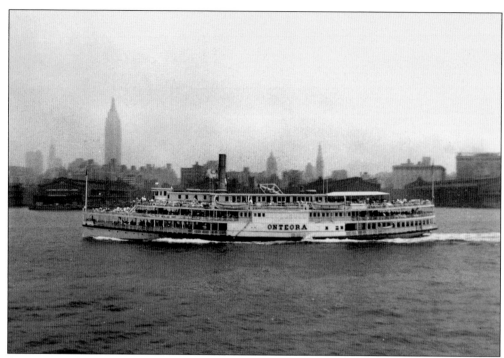

As mentioned in chapter two, the *Onteora* and *Clermont* were built as night boats for the Catskill Evening Line. After that company went into receivership, both steamers were purchased in 1919 by Palisades Park commissioner George Walbridge Perkins. Their staterooms were removed, and they were converted to day boats. George Perkins was a great supporter of Bear Mountain Park and intended the steamers to bring more people up from the city. He died in 1920, and the steamers were purchased with funds from the Laura Spellman Rockefeller Memorial and turned over to the park commission. In 1923, the McAllister Line entered into an agreement to operate the steamers for the commission and eventually purchased them both. (Both, photographs by Donald C. Ringwald; courtesy of the Hudson River Maritime Museum.)

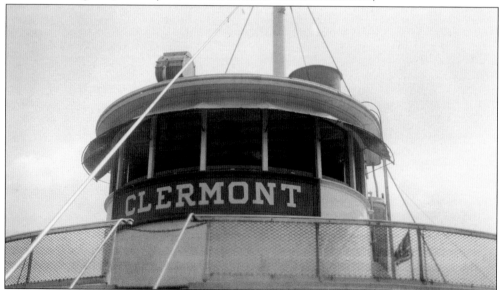

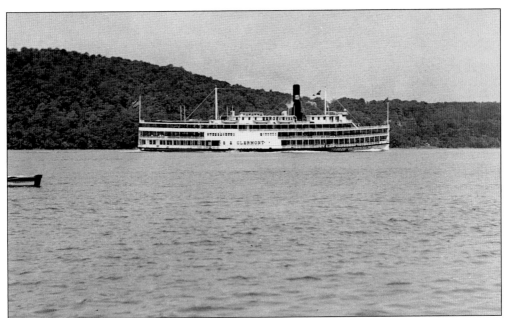

The McAllister fleet was auctioned off in 1939, and the *Clermont* went to Charles Sutton. She is shown here while operating on the Sutton Line. In 1947, she was renamed *Bear Mountain*. (The previous steamer of that name had been sold for service on Chesapeake Bay.) This *Bear Mountain* continued on the Bear Mountain run until her last trip on Labor Day 1948. (Photograph by William H. Ewen Sr.; author's collection.)

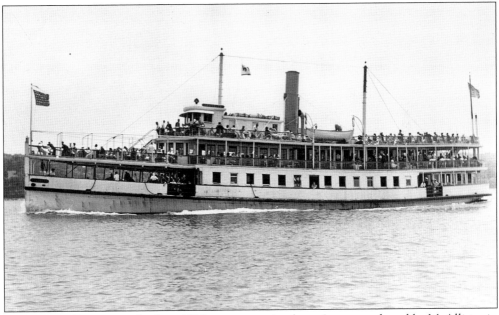

The steamer *Favorite* was built in 1894 as an excursion boat. It was purchased by McAllister in 1925 because the company needed another vessel for charters. This unimposing steamer had the distinction of being the first American triple-screw merchant vessel. It was later converted to two screws. In this view, she is off Irvington on June 19, 1938. (Photograph by William H. Ewen Sr.; author's collection.)

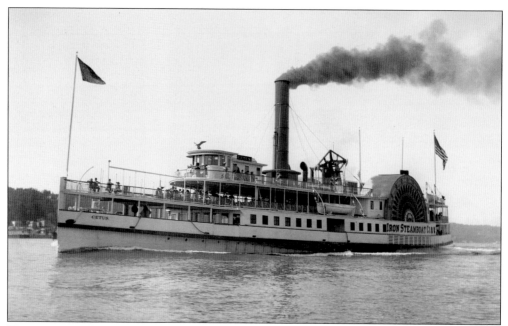

The Iron Steamboat Company had a fleet of seven iron-hulled side-wheelers that were operated to Coney Island and Rockaway. Steamers from this company and its successors often made excursion trips on the Hudson. The *Cetus*, shown here, was built in 1881. When the company's fleet was auctioned off in 1932, the *Cetus* was purchased and renamed *Reliance*. (Photograph by Edwin Levick; author's collection.)

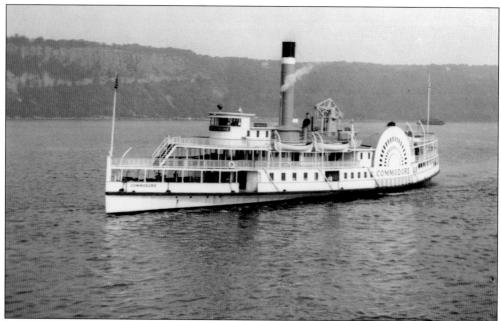

The *Commodore* had been the Iron Steamboat Company's *Taurus*. She is pictured here approaching City Pier at Yonkers with her whistle blowing. Empty decks indicate that she is probably arriving to pick up passengers for a special excursion or charter. (Photograph by William H. Ewen Sr.; author's collection.)

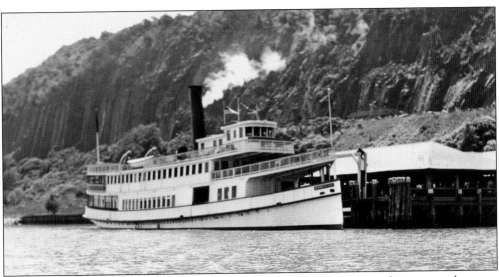

The *Ossining* was built in 1885 as the *Sarah Jenks* and carried freight and passengers between Ossining and New York. Once a prisoner from Sing Sing attempted to escape hidden in a case of shoes the boat was transporting, but he was caught. About 1918, the *Sarah Jenks* was converted into an excursion steamer and renamed *Ossining*. She is shown at Hook Mountain Park. (Photograph by William H. Ewen Sr.; author's collection.)

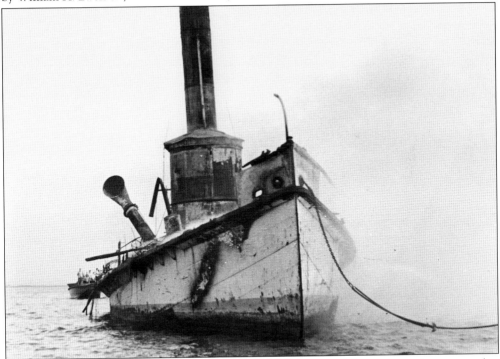

In 1949, after being laid up for several years, the *Ossining* was towed down river to be converted to a fishing vessel. Off Piermont, a suspicious fire broke out, leaving only the smoldering iron hull, boiler, and machinery. Notice that the rope-towing hawser is attached to a long length of chain rather than directly to the steamer, perhaps indicating that the crew was expecting something. (Photograph by William H. Ewen Sr.; author's collection.)

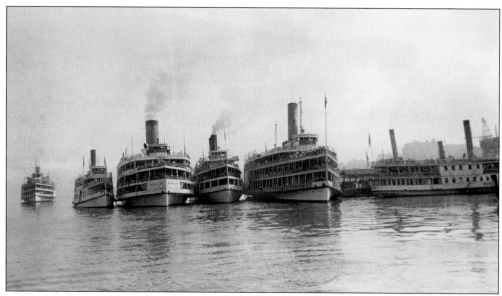

The preacher Father Divine would charter steamers to take his followers from Harlem upriver to "Father Divine's Retreat" at Krum Elbow, opposite Pres. Franklin Roosevelt's home. Father Devine painted the initials FDR on his roof, amusing the president but not his mother, Sarah Roosevelt. Loading are, from left to right, *Ossining*, *State of Delaware*, *City of Keansburg*, *Clermont*, and *Susquehanna*. Waiting is the *Peter Stuyvesant*. (Photograph by Donald C. Ringwald; courtesy of the Hudson River Maritime Museum.)

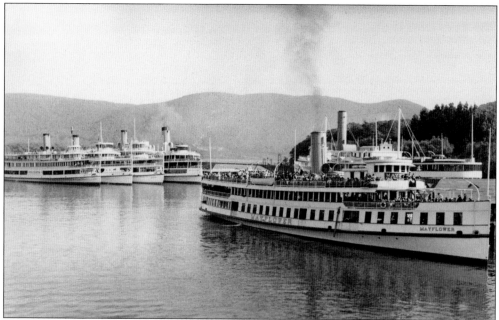

Another "group photograph" gives evidence of the popularity of Bear Mountain as an excursion destination. From left to right are the steamers *Wauketa*, *Westchester*, *Americana*, *State of Delaware*, and *Mayflower*. Behind is the *Clermont*. The *Mayflower* was built as the *Moosehead* for service in Maine and was the sister ship of the Day Line's *Chauncey M. Depew*. (Photograph by William K. Covell; author's collection.)

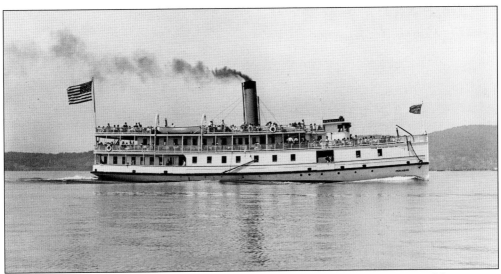

The steamer *Pemaquid* was built in 1893 as the *Long Island*. Shortly after the turn of the century, she was placed in service on the Maine coast by the Maine Central Railroad. The vessel left Maine in 1931. Here, she is off Piermont on June 19, 1938, bound for Bear Mountain. She last operated as a dieselized ferry to Block Island. (Photograph by William H. Ewen Sr.; author's collection.)

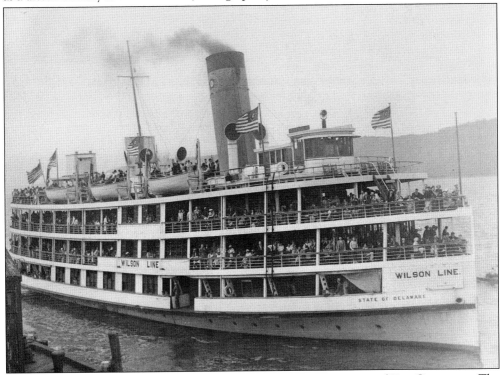

The Wilson Line, based in Delaware, operated excursion steamers in several East Coast ports. The company came into the New York market in 1936 with the steamer *State of Delaware*. Designed by George Sharp, the Wilson Line vessels had a more modern appearance than most others. The *State of Delaware*, built in 1923, still had a traditional pilothouse and tall stack. Here, she is landing at Yonkers.

The Wilson Line's *State of Pennsylvania,* also built in 1923, was a sister ship of the *State of Delaware.* In 1944, she was reconditioned, including adding a raked and enclosed bow and a more streamlined stack. The steamer is seen here off the Palisades after remodeling, heading for Bear Mountain. She was retired in 1960. (Photograph by William H. Ewen Sr.; author's collection.)

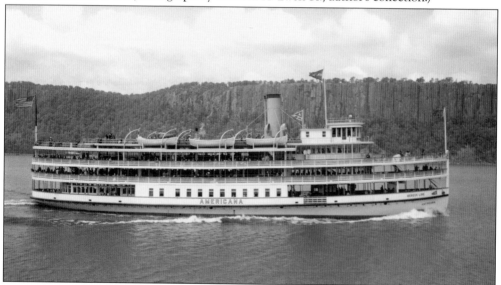

The Meseck Line operated a fleet of excursion steamers in the New York area, mostly to Rye Beach. The *Americana* was built in 1908 for service out of Buffalo and purchased by Meseck in 1930. She made many spring and fall charter trips up the Hudson, as well as a popular "Showboat Review and Dance Cruise" on Saturday nights. She was scrapped in 1953.

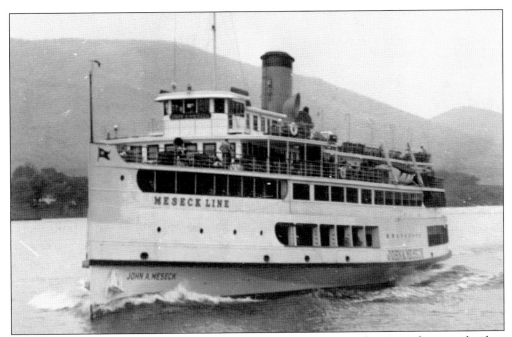

The *John A. Meseck* was built in 1929 as the *Naushon* for service to the Massachusetts islands of Martha's Vineyard and Nantucket. She was taken by the government during World War II and crossed the Atlantic with a fleet of similar steamboats. The vessel was used as a transport on the English Channel and was *Hospital Ship 49* at Normandy during the invasion.

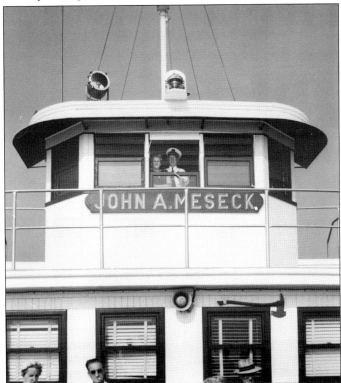

After the war, she was acquired by the Meseck Line, renamed *John A. Meseck*, and completely rebuilt for the Rye Beach service. Like the company's *Americana*, she often ran excursions and charters up the Hudson. In 1957, she was sold to the Wilson Line and continued in service through 1961. In this view, Capt. Dewitt Robinson and his wife pose in the pilothouse window.

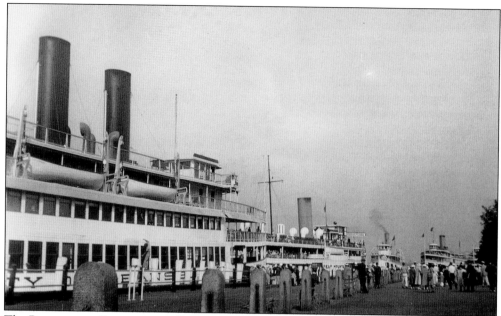

The Battery seawall was a major departure point for New York excursion steamers. From left to right are the *City of Keansburg, Bear Mountain, Hook Mountain,* and *Wuaketa.* All ran excursions on the Hudson. The *City of Keansburg* was built in 1926 for service to Keansburg Beach and later to Atlantic Highlands. Retired in 1968, she was one of New York's last excursion steamers. (Photograph by Donald C. Ringwald; author's collection.)

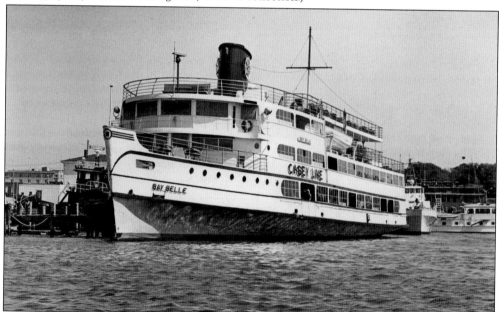

Although the *Bay Belle* did not look like a traditional steamboat, she was the last passenger steamer in New York area. Built by the Wilson Line in 1910 as the *City of Wilmington,* the vessel originally had a more traditional appearance but was completely rebuilt in 1941 with a modern steel superstructure. She changed hands several times and ended her career in 1976 as *The Dutchess.* (Photograph by author.)

Five

SMALL DAY BOATS

Although they did not attract as much notice as the larger steamers, there were a great number of smaller day boats in different services on the river. Some ran out of Albany, and others ran from New York to landings on the lower river. Many operated between towns on the river and rarely went north or south to the major cities. While some of these vessels were strictly passenger boats, others carried freight as well.

The smaller steamers were extremely important to the lives of the towns they served. These communities were not large enough to attract the bigger steamers that stopped at the major landings, so the smaller vessels were the connection to the centers of commerce on both sides of the river. Still others carried freight and passengers between larger upriver landings, and some served as commuter boats to cities on the river.

This chapter will feature some of the interesting, but perhaps lesser known, day boats and the services they operated.

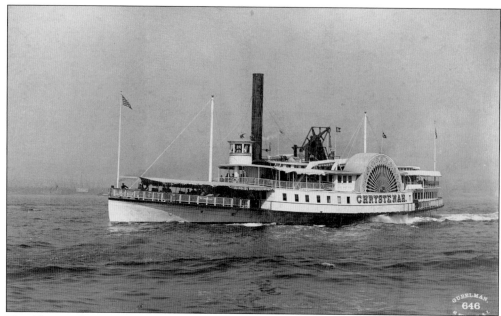

The *Chrystenah* was built at Nyack, New York, in 1866, and with a walking beam engine and large paddle boxes, she was typical of the smaller side-wheel passenger steamers of the later 1800s. She is shown here as originally built with a round or "sentry box" pilothouse and fan decorations on the paddle boxes. (Photograph by Gubelman; author's collection.)

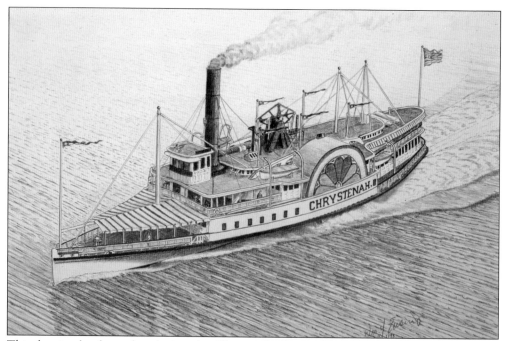

This drawing by the author depicts the *Chrystenah* after modifications of 1906. She received a new pilothouse as well as simpler paddle box decorations. The graceful elliptical shape so typical of these steamers is clearly evident. The vessel operated as a commuter boat to New York from Nyack and Peekskill, stopping at small towns along the way. (Courtesy of Chrystena Ewen.)

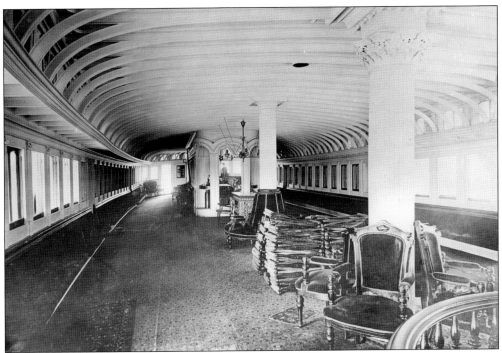

This is the *Chrystenah's* main saloon. Being a day boat, she had no staterooms for overnight passengers. In addition to her regular lower river service, the steamer was sometimes used by other lines to provide extra passenger capacity and for special trips. She was retired about 1918 or 1919 and ended up as a derelict at New Rochelle, New York.

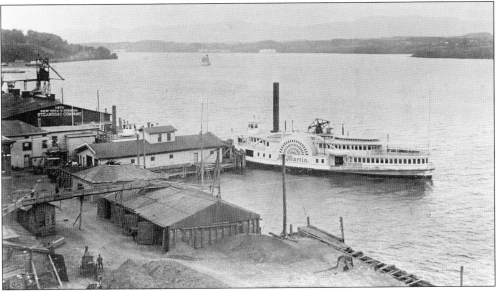

In addition to night boats, Romer & Tremper operated a day line between Newburgh and Albany with the steamers *M. Martin* and *Jacob Tremper*. Like the company's night boats, these vessels became part of the Central Hudson Line. The *M. Martin* was built in 1863 at Jersey City. In this view, she is at the landing at Hudson. She originally had a round or "sentry box" pilothouse, as shown here.

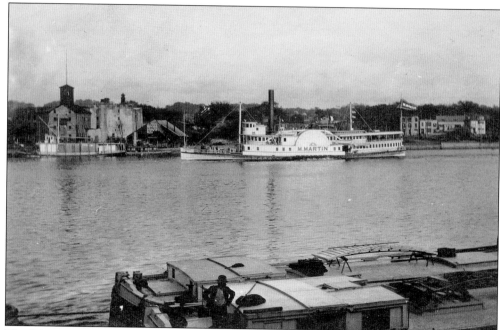

The M. *Martin* appears here after being rebuilt. She is likely leaving Albany on the way to Newburgh, with stops at numerous landings along the way. Business dropped off on this run, and she was laid up in 1917 and scrapped two years later. Her hull was taken to Eavesport to be used as a wharf. The vessel's remains are still there.

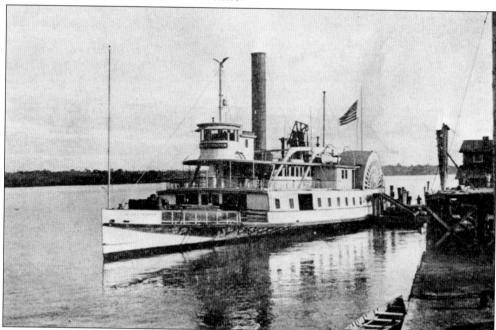

The *Jacob H. Tremper* was built at Greenpoint, New York, in 1885 by Lawrence & Foulks. This postcard view shows her at Coxsackie on a northbound trip. She carried freight on her open main deck as well as inside the deckhouse. Note the gilded eagle at the masthead above the pilothouse.

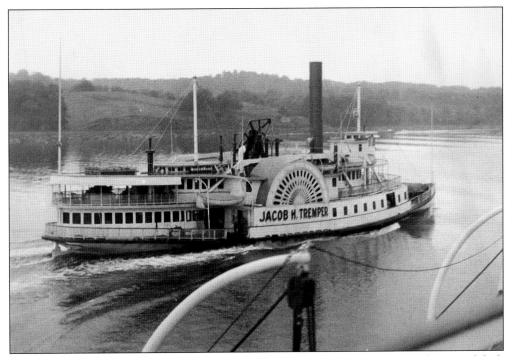

The *Jacob H. Tremper* is in the narrow upper river. There are a few passengers on the second deck aft, and she appears to have a good load of freight up forward. This view was taken from a passing Day Line steamer. Most of the officers of these steamers knew each other and would exchange whistle salutes when passing.

After the *M. Martin* was retired, the *Jacob H. Tremper* carried on the Newburgh–Albany run alone until her last trip in December 1928. The following year, she was scrapped at Newburgh, as shown here. The A-frame that held her walking beam was later used on-site to support a conveyor and survived well into the 1950s. (Photograph by William H. Ewen Sr.; author's collection.)

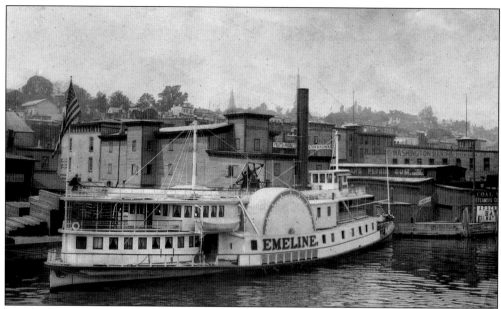

The steamer *Emeline* was built as the *Nantasket* in 1857 for service out of Boston. During the Civil War, she was chartered by the US Quartermaster's Department, was captured, and the crew spent time in Libby Prison. Renamed *Emeline*, she returned to Boston in 1865. In 1883, the steamer was purchased by Capt. David Woolsey for service on the Hudson. In this view, the vessel is at Newburgh.

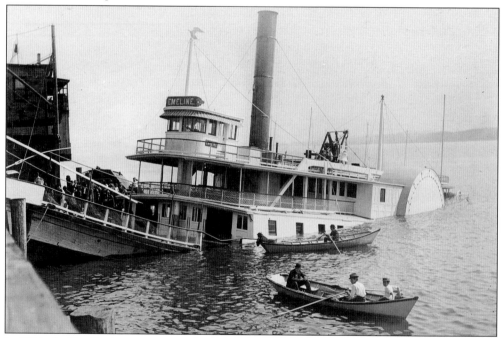

In 1894, the *Emeline* began carrying freight and passengers between Haverstraw and Newburgh. This photograph shows her after ramming the dock at Newburgh in a heavy fog. The vessel was repaired and continued in service until 1916. The following winter, she was wrecked by ice while laid up at Haverstraw.

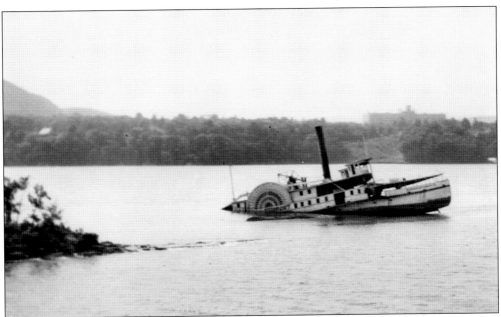

The steamer *Point Comfort* was built as the *Nantucket* in 1886 for service to the islands of Martha's Vineyard and Nantucket. She was purchased and renamed by the Keansburg Steamboat Company in 1913. A group of Catskill businessmen who wanted increased freight service chartered the steamer in 1919. On her second trip on the river, she was wrecked in heavy fog on the north end of Esopus Island.

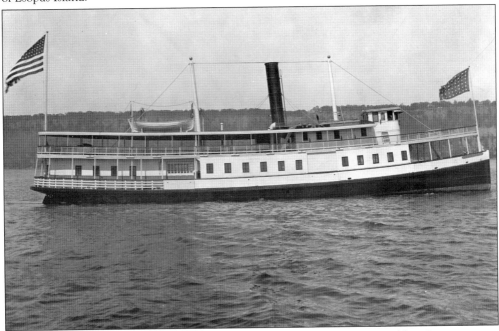

The *Benjamin Franklin* was built at Staten Island in 1894 for the Ben Franklin Transportation Company. She operated between Yonkers and New York, carrying both passengers and freight. On occasion, she was also available for charters and excursions. The vessel was laid up at Yonkers in 1931 and later sank at her wharf.

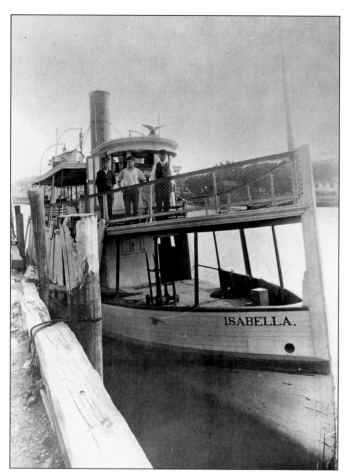

The *Isabella* was built at Athens in 1882 and operated until 1915. At different times, the little steamer served Catskill, Hudson, Athens, and Castleton. She carried passengers, and as the handcarts on the deck indicate, she also carried freight. In this view, she is at her wharf on Catskill Creek.

The side-wheeler *Victor* was originally the *John L. Lockwood* when she was built as a New York tugboat in 1854. The boat was taken for Civil War service and then returned, renamed *Henry L. Smith*. After another stint with the government, she was rebuilt, renamed *Victor*, and sold for use on the Hudson and Long Island Sound. In 1912, she began operating between Albany and Troy and was sold several years later.

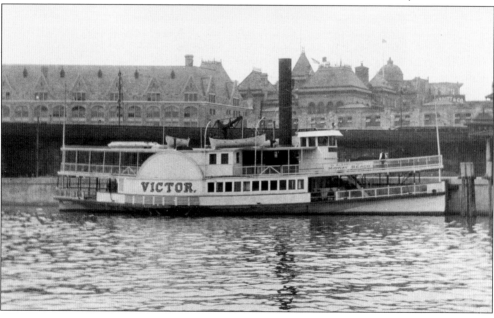

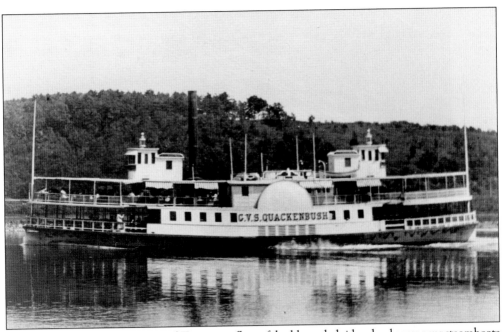

Also running between Albany and Troy was a fleet of double-ended side-wheel passenger steamboats operated by the Albany-Troy Steamboat Company. They ran half-hour trips between the two cities, stopping at Midway Beach in each direction. Thousands took advantage of the 10¢ trips on hot summer evenings. The G.V.S. *Quackenbush*, built at New Baltimore in 1878, was typical of these steamers.

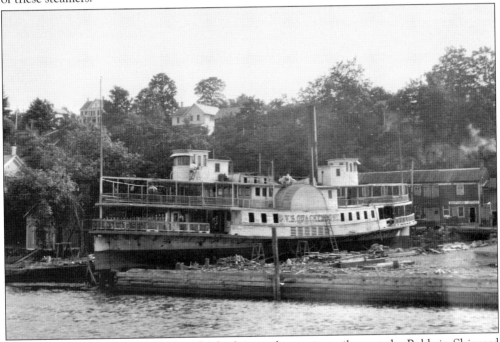

Looking a bit seedy, the G.V.S. *Quackenbush* is on the marine railway at the Baldwin Shipyard in New Baltimore, where she had been built. There are few traces of the yard in existence today, but the shipyard manager's house, on the far left, is still standing.

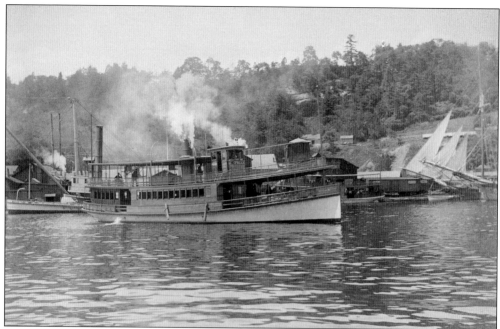

The steamer *Priam* was built at Rondout (Kingston) in 1892 and had a sister ship, the *Pilot*. The *Priam* ran on the upper river mostly between Albany and Troy. She was later rebuilt and renamed *General J.B. Carr*. This photograph shows her on Rondout Creek with the whistle blowing, possibly when brand-new. Behind her bow, in the background, is probably the *Pilot*.

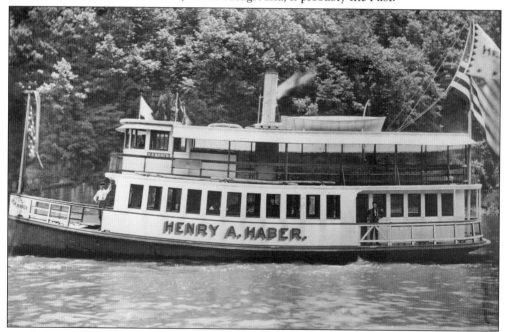

Rondout was the homeport of a number of small steamers that ran to towns such as Glasco, Malden, and Poughkeepsie as well along Rondout Creek itself. The *Henry A. Haber* was built at Newburgh in 1896 and was 65 feet long. She operated mostly on the creek, from the mouth at the Hudson River, to Eddyville, where the Delaware and Hudson Canal terminated.

Six

MOVING FREIGHT

Passenger steamers were in the majority on the river, whether used as transportation or strictly for pleasure. However, the movement of freight was an equally important part of the transportation system on the Hudson. Most of the night boats carried both passengers and freight, and some of the night lines also had freight steamers to supplement the larger vessels. In addition, most of the smaller day boats carried both freight and passengers. Without the revenue from freight, it is unlikely that any of these lines would have lasted as long as they did.

There were also freight steamers that were not part of the larger companies. These vessels were usually smaller and carried few passengers. Some of these will be included in this chapter.

Another very important means of moving freight was by tug and barge. The largest tugboat company on the river above New York was the Cornell Steamboat Company, based on Rondout Creek at Kingston. Rondout became an important port because the Delaware and Hudson Canal, transporting coal from Pennsylvania to the Hudson, terminated at the upper end of Rondout Creek. Many thousands of tons of coal were transferred from small canal barges to larger river barges for movement down river. Barges also carried ice, bricks, stone, and package freight, to name a few things. Perishable items like fruit and vegetables usually went by the faster steamboats.

Barges could not move without tugboats. Although less glamorous than most of the passenger steamers, they had a charm of their own, and some were quite handsome.

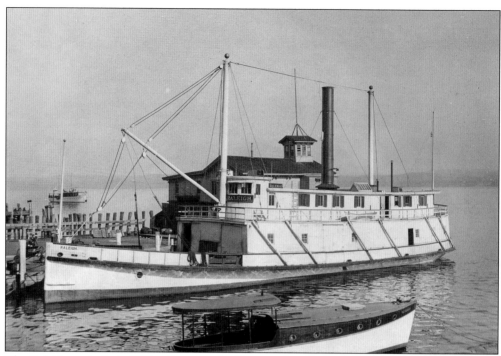

The *Raleigh* was built in 1872 at Portsmouth, Virginia, for service on the Potomac River. She was purchased by the North River Steamboat Company and for many years ran between New York and Haverstraw, stopping to deliver freight at villages along the way. When customers would place an order, village merchants would often say, "It will be up on the *Raleigh*." She was broken up in 1926.

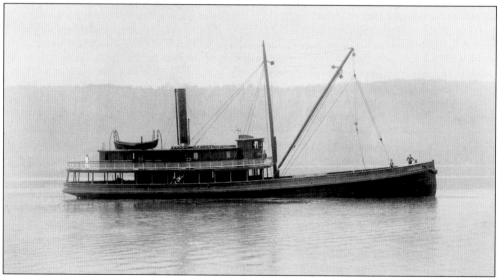

There was a series of large cable companies at Hastings-on-Hudson. A small fleet of freight steamers, operated by the New York and Hastings Steamboat Company, served this waterfront business. They would deliver raw products like copper and brass and take away reels of finished cable. Boats like this with booms and masts for self-unloading were known as lighters. This is the *Hastings* posing with her crew.

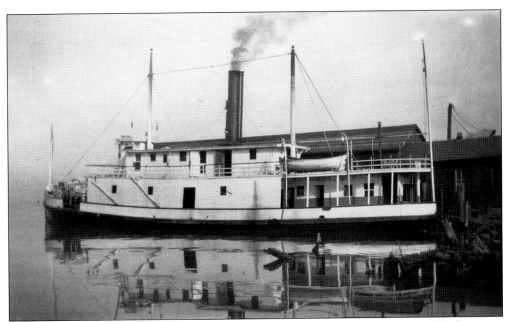

The wooden freight boat *Fannie Woodall* was built at Wilmington, Delaware, in 1878. For many years, she operated between New York and Peekskill on the lower Hudson. She was one of several vessels operated by Morton's Peekskill Day Line. In this view, she is at her Peekskill wharf on a calm summer day with a deck load of freight.

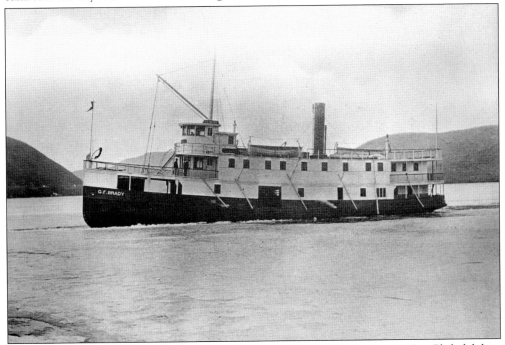

The *G. F. Brady* is breaking her way through the ice off Peekskill. Built in 1897 at Philadelphia, her first homeport was Wilmington, Delaware. During the 1920s, the vessel was operated as a freight boat by Morton's Peekskill Day Line. In October 1926, she was capsized in a heavy squall off Irvington, resulting in the boiler exploding.

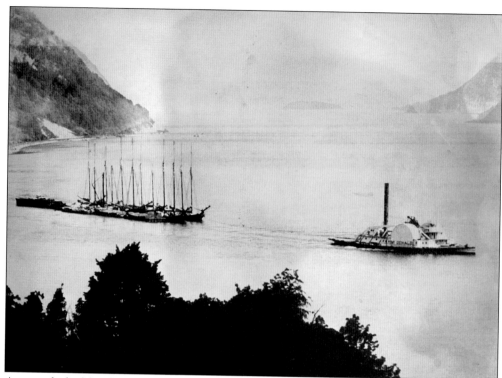

A great deal of freight was moved by tugboats. This photograph shows the side-wheel towboat *General McDonald* with a tow of barges and schooners. Built as a passenger steamer in Baltimore in 1851, she was purchased by Jeremiah Austin in 1855 and converted to a towboat. Thomas Cornell purchased the vessel in 1876 and operated her until she was scrapped in 1905. (Roger W. Mabie collection; courtesy of the Mabie family.)

The side-wheel towboat proved to be a good means of moving large fleets of barges on the river in the 19th century. The first ones were converted passenger steamers. The *Norwich* was built in 1836 for passenger service on Long Island Sound. In 1848, she was purchased by the Cornell Company and converted for towing. The *Norwich* retired in 1917 as the oldest operating steamboat in the world.

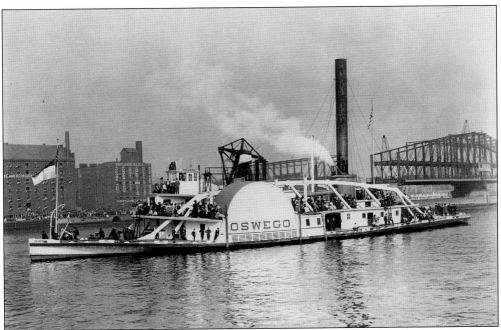

The *Oswego* was the first side-wheeler specifically built for towing on the Hudson. She was in service from 1848 until September 1918. In this view at Albany, she is participating in the Hudson-Fulton Celebration of 1909. The flag at her bow is the official flag of that celebration. Being a towboat, the *Oswego* had no railings to keep passengers from going over the side.

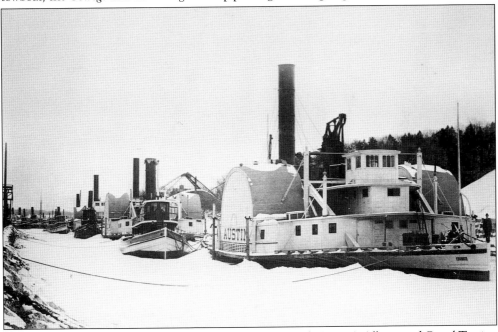

The side-wheel towboat *Austin* was built in 1853 for Jeremiah Austin's Albany and Canal Towing Line. Thomas Cornell purchased her in 1876 for his Rondout-based company. This photograph shows her laid up at Rondout for the winter, along with a large fleet of side-wheel and propeller tugs. The *Austin*'s last year of service was 1898.

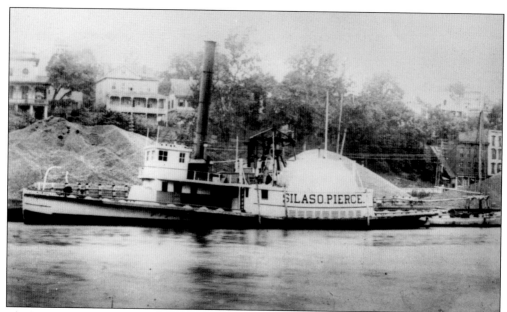

The small side-wheel towboat *Silas O. Pierce* was built at Athens in 1863 for Thomas A. Briggs. She was chartered to the government during the Civil War. After the war, the vessel transported Confederate president Jefferson Davis to prison at Fortress Monroe. In 1865, she was sold to Jeremiah Austin, then to Thomas Cornell in 1876. The *Pierce* was scrapped in 1911. Here, she is at Island Dock in Rondout.

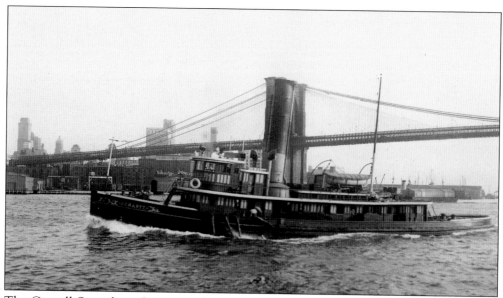

The Cornell Steamboat Company also operated a large fleet of handsome propeller tugs. The *J.C. Hartt* was built for the company in 1883. Larger tugs like this did much of the towing of rafts of barges on the river, alone or with other tugs. In this view, the *Hartt* is heading up the East River, probably to pick up barges for delivery on the Hudson.

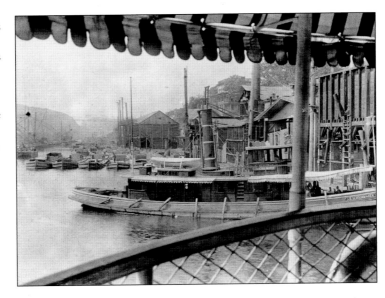

This view of Rondout's waterfront was likely taken from the *William F. Romer*. In the foreground is the 1888 Cornell tug *John D. Schoonmaker*. Over the years, her appearance changed several times, and this is the boat early on. In 1951, she was sold and renamed *Downer V*, which was scrapped three years later. (Courtesy of the Ringwald Collection, Hudson River Maritime Museum.)

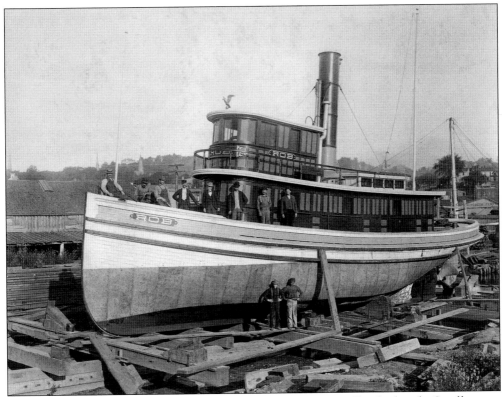

The small 1902 tug *Rob* is hauled out on a marine railway at Sleightsburgh. Smaller tugs like this worked on Rondout creek and also acted as helpers on river tows, aiding in steering them. They would also drop off and pick up barges along the way as the tow continued to move. The *Rob* was sold in 1941 and finally scrapped in 1963. (Courtesy of the Ringwald Collection, Hudson River Maritime Museum.)

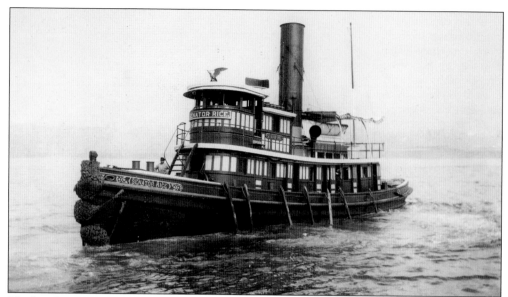

The handsome tug *Senator Rice* was built at Rondout in 1902 for several partners in Kingston and Brooklyn. In 1907, she was purchased by the Cornell Steamboat Company and was operated by that company until 1946, when she was scrapped. The boat has the two-color paneling on the deckhouse that was typical of many Cornell tugs.

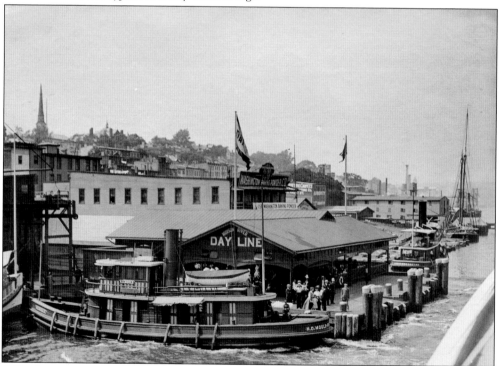

A Day Line steamer has just departed the wharf at Newburgh, and her wake is rocking the Cornell helper tug *H. D. Mould*. The *Mould* was built at Athens for the Foster-Scott Ice Company. She was purchased by Cornell in 1904 and finally abandoned in 1943. (Courtesy of the Ringwald Collection, Hudson River Maritime Museum.)

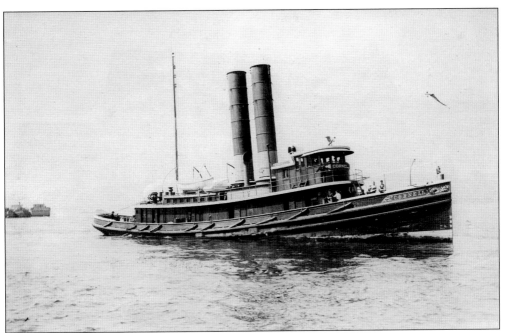

The *Cornell* (I) was built in 1902. Over the years, she had several battles with ice. In 1910, there was an ice jam at Albany, threatening to flood the city. The government asked Cornell to send its biggest tug to break it. The *Cornell* had to bust through two-foot-thick ice to reach Albany, where she successfully broke the dam. In 1917, the vessel was sold and renamed *Istrouma*.

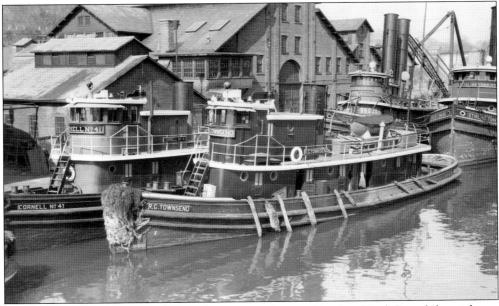

Several Cornell tugs are tied up here at the company shops on Rondout Creek. From left to right are the *Cornell No. 41*, built in 1900; the *R. G. Townsend*, built in 1882; the *George W. Washburn*, built in 1890; and the *Stirling Tompkins*, built in 1919. The large building in the background is still standing today. (Photograph by Donald C. Ringwald; courtesy of Hudson River Maritime Museum.)

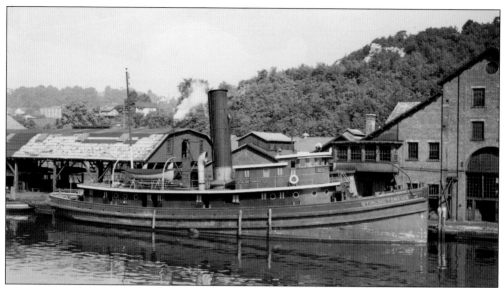

The 150-foot *Stirling Tompkins* is at the Cornell shops on a quiet summer day. She was built in 1919 at Solomons, Maryland, as the *Artisan*, for the US Shipping Board. In 1920, the boat was sold to the Cahill Towing Line and to Cornell in 1930. She operated on the river until 1948. The following year, the *Tompkins* was scrapped at Cornwall. (Photograph by Donald C. Ringwald; courtesy of Hudson River Maritime Museum.)

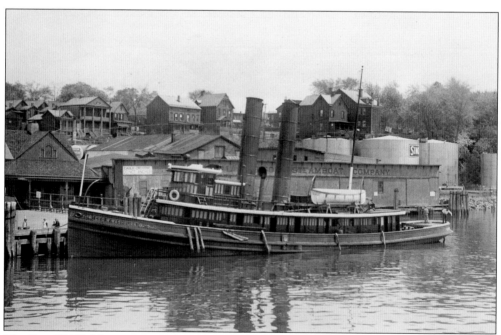

The *Geo. W. Washburn* was considered by many to be one of the handsomest tugs on the Hudson River. She was built in 1890 at Newburgh and, in 1921, was rebuilt with new boilers, a single stack replaced with two. She is laying at Poughkeepsie and several crewmen are fishing off the stern. The *Washburn* was scrapped in 1949 at Cornwall. (Photograph by William H. Ewen Sr.; author's collection.)

Seven

GETTING ACROSS

The Hudson River was an important highway for the north-south movement of people and goods. However, it also created a barrier to east-west commerce. The initial solution to this was ferryboats, the earliest ones being nothing more than rowboats or small sailing craft. Some of the first charters for the operation of Hudson River ferry crossings went back to British colonial times.

With the development of steam vessels, the ferry lines became more numerous, the capacity of the boats greatly increased, and the crossing times were reduced. Over the years, there were many different ferry lines on the river but not all at the same time. As one steamboat man said years ago, "If all the ferries licensed to cross the Hudson were operating at the same period, there would not have been much room for 'up and down' steamboatin'."

Many of the ferry lines were not extensions of major roads but rather were important links for the towns they served. At first, the growth of the automobile resulted in an increase in the number of ferryboats. Eventually, however, ferries could not handle the huge numbers of private autos. One by one, the inevitable bridges brought about the end of ferry crossings on the river. The last one north of New York ended service in 1963.

This chapter focuses on some, but not all, of the ferry lines and vessels that crossed the river above the city.

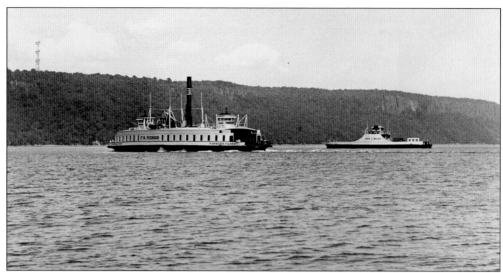

There had been several unsuccessful attempts to operate a ferry at Yonkers in the 19th century. In 1923, the Westchester Ferry Corporation was established to run a Yonkers-Alpine ferry. The company's first vessels were two former Hoboken ferries, the *Paunpeck* and *Musconetcong*. The latter was renamed *F. R. Pierson* and is seen in later years with the diesel *John J. Walsh*. (Photograph by William H. Ewen Sr.; author's collection.)

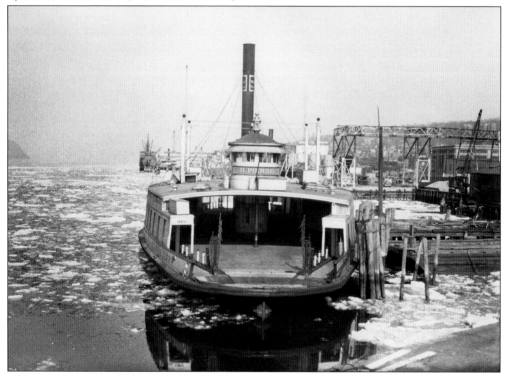

The *F. R. Pierson* was built at Newburgh in 1885 for the Lackawanna Railroad. She was purchased for the Yonkers and Alpine service in 1923 and ran until retired in 1945. That year, the propeller ferry *Leonia* replaced her. In this view, the *Pierson* is laid up at Yonkers in February 1946. She was the last side-wheel ferry on the Hudson. (Photograph by William H. Ewen Sr.; author's collection.)

Many ferries in the New York area often had one or two musicians aboard. They would wander the car deck playing for tips. These two gentlemen were providing musical accompaniment to a crossing on the Yonkers ferry. Traffic on this line declined drastically after the Tappan Zee Bridge was opened in 1955, and the ferry shut down in December 1956.

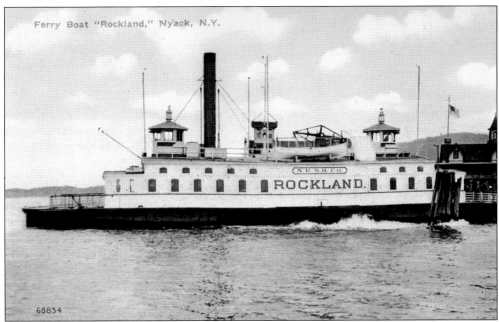

Between 1912 and 1926, there were two competing ferry lines between Tarrytown and Nyack. They were the older North River Steamboat Company and the North River Ferry Company. The *Rockland* was the best known of the North River Steamboat Company's vessels. She was built at Athens in 1888 and ran through the 1925 season. The ferry ultimately ended up as a summer home in Perth Amboy, New Jersey.

Capt. John Lyon, master of the *Rockland*, was one of the most colorful ferryboat men on the Hudson. A man of fierce pride and unmatched skill, he was a favorite of many passengers who made a point to visit with him on the crossings. These included Horace Greeley, Adm. David Farragut, and John D. Rockefeller. At 88, Lyon was said to be the oldest active skipper in the world.

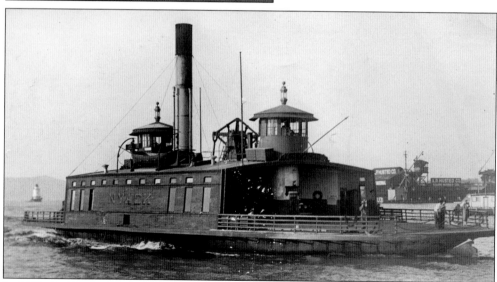

In 1926, the North River Ferry Company bought out the North River Steamboat Company and continued to operate the Tarrytown–Nyack service. One of its vessels, the *Nyack*, was built in 1903 as the *Ocean City* and originally ran on the Delaware River. In this view, she is approaching the Tarrytown slip with her engines stopped. In the background is the Tarrytown lighthouse.

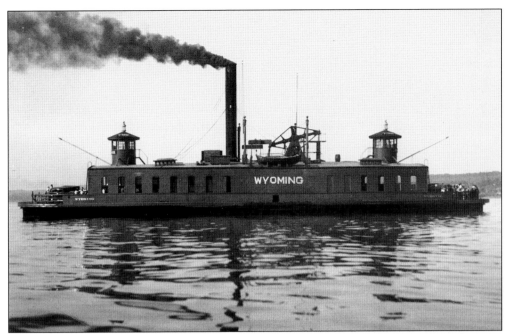

The *Wyoming*, a former New York City ferry built in 1885, came to the Tarrytown–Nyack run in 1935. In November 1941, she made the last trip of the line, at that time the oldest crossing on the Hudson above New York. It was said that the saddest person at the time was a young Tarrytown man whose girlfriend lived in Nyack. (Photograph by William H. Ewen Sr; author's collection.)

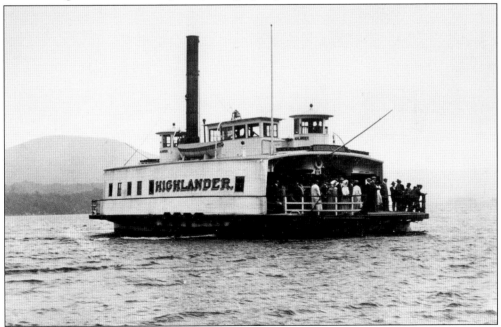

The Garrison & West Point Ferry Company was incorporated in 1854, and its first steam double-ender, the *West Point*, went on the run in 1858. In 1876, she was replaced by a new side-wheeler, the *Highlander*. She is shown here approaching the ferry slip at West Point. The *Highlander* had a walking beam, but it is covered by the house on the top deck.

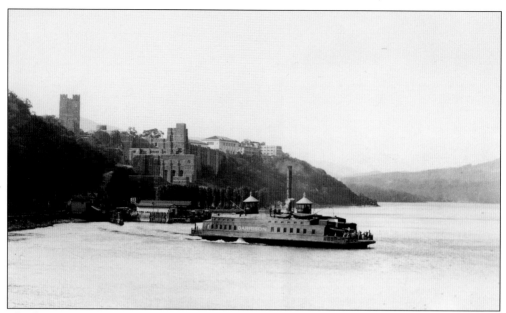

The ferry *Garrison* was built in 1887 as the *General Hancock*. In this view, she has just departed West Point and is heading for Garrison with vehicles and passengers. The Bear Mountain Bridge, several miles downstream, took most of the traffic from the line, and it ceased operation in the fall of 1928. The *Garrison* went to pieces in the Garrison slip, and her remains are there today.

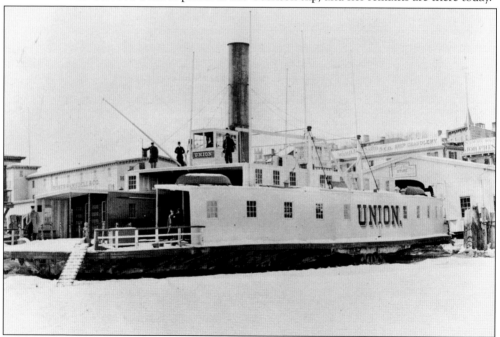

The ferry line between Newburgh and Fishkill (later called Beacon) operated under a charter granted by King George II in 1742 and, by the time it ceased running, was the oldest in the country. The steamer *Union*, shown locked in the ice at Newburgh, was built in 1844. She was purchased by the Newburgh and Fishkill Ferry Company in 1860 and ultimately burned at Newburgh in 1878.

The engine from the *Union* was used in a new ferry, the *City of Newburgh*, built at Newburgh in 1879. The boat operated until 1939, when she was scrapped at East Kingston. That totaled 95 years of service for the engine. In this view, the vessel is approaching the Newburgh slip, with her engines stopped.

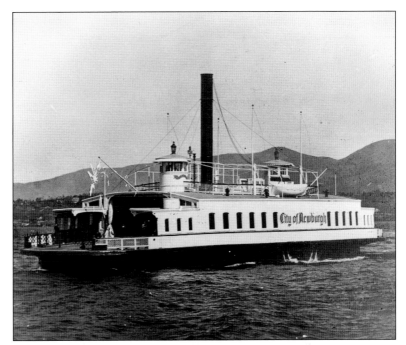

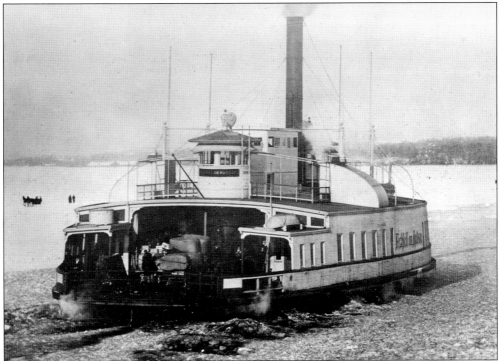

In 1884, the *Fishkill-on-Hudson* was built for the Newburgh–Fishkill service. Like the *City of Newburgh*, she had an iron hull that could withstand the winter ice. Here, the boat is following a track that the ferries kept open. Notice the sleighs on board, loaded with freight. In 1915, the vessel was sold for service on Long Island Sound. Later renamed *Jamestown*, she ran between Newport and Jamestown, Rhode Island.

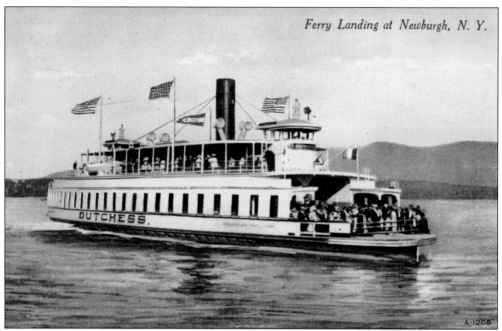

In 1910, the company built the *Dutchess*. She was built at the Marvel shipyard in Newburgh and was the first screw-propelled double-ended ferry on the river above New York. In 1961, she burned at Newburgh and was rebuilt with unattractive boxes for pilothouses and no second deck for passengers. This postcard shows the ferry when fairly new.

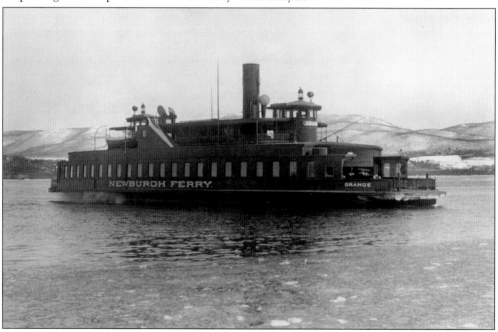

In 1914, a sister ship to the *Dutchess*, the *Orange*, was built. She was painted Tuscan red because the white of the earlier ferries was so hard to keep clean. The others were repainted red about the same time. When the New York State Bridge Authority took over the line from the descendants of Homer Ramsdell in 1956, the boats were repainted dark green.

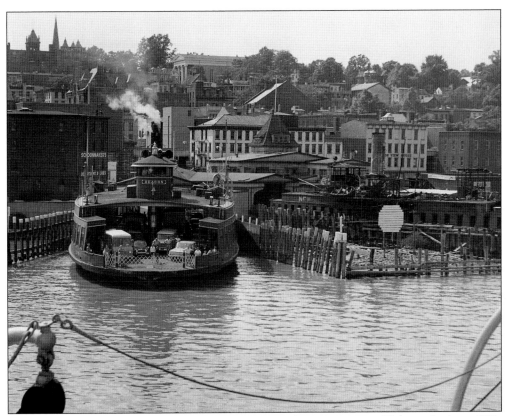

In 1938, the company purchased the former Boston ferry, *Lieutenant Flaherty*, built in 1921. Renamed *Beacon*, she ran on the line, often as a spare boat, until the end of service. The *Beacon* did not have a second passenger deck, as can be seen in the view at Newburgh. To the right is the burned-out *Dutchess*. (Photograph by author.)

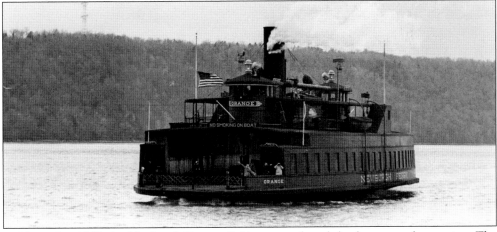

In November 1963, the Newburgh-Beacon Bridge opened, and the ferry ceased operation. The *Dutchess* and *Beacon* were sold for scrap. The *Orange* was purchased for excursions to the 1964 New York World's Fair. Here, she is blowing a salute passing Yonkers, on her way down river after being sold. The author was aboard as part of the volunteer crew. She was scrapped in 1966. (Photograph by William H. Ewen Sr.; author's collection.)

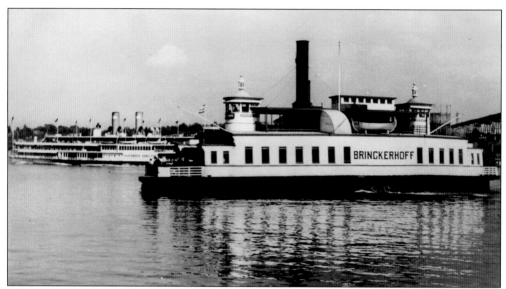

There had been a ferry crossing at Poughkeepsie by the late 1700s, and a steam vessel, the *Dutchess and Ulster*, by 1834. In 1899, the Poughkeepsie and Highland Ferry Company replaced an 1861 ferry, *Joseph C. Doughty*, with the *Brinkerhoff*. In this photograph, she is coasting to the slip at Highland, while the *Alexander Hamilton* passes in the background.

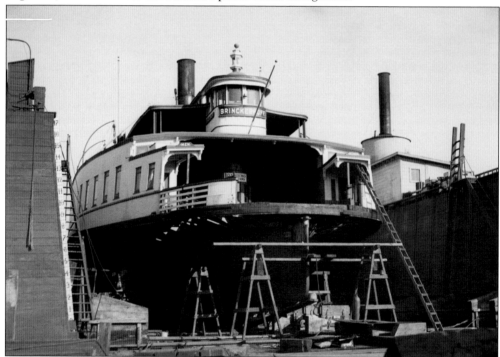

The *Brinkerhoff* is seen in dry dock in 1936. She closed out the Poughkeepsie–Highland service in 1941 and was sold to the City of Bridgeport, Connecticut. After serving as an excursion boat, she was donated to the Mystic Seaport. Although she was a popular exhibit, some directors at the time felt that she was not historic enough. The vessel was ultimately sold and burned for scrap. (Photograph by William H. Ewen Sr.; author's collection.)

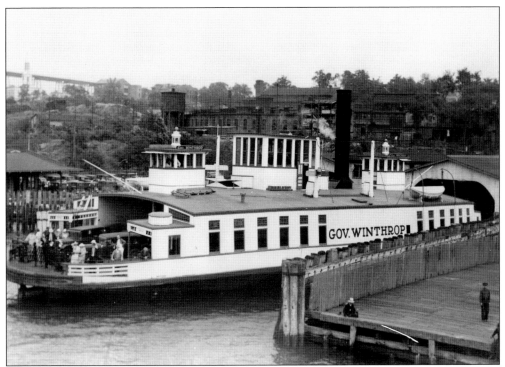

Another ferry of the Poughkeepsie–Highland route was the *Governor Winthrop*. She was built in 1905 for service between New London and Groton, Connecticut. In 1921, the Poughkeepsie and Highland Ferry Company purchased the boat to run with the *Brinkerhoff*. She was laid up in 1938 and scrapped in 1942. Here, the *Governor Winthrop* is seen in the slip at the foot of Main Street in Poughkeepsie. (Photograph by William K. Covell; author's collection.)

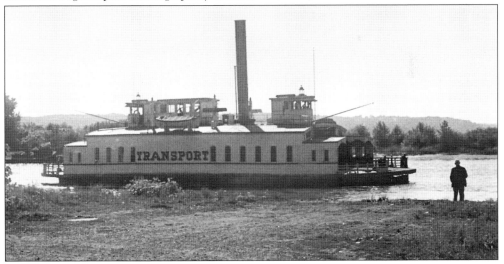

Ferry service between Kingston and Rhinecliff dated back to the early 1700s. The first reference to a steam ferryboat was in 1845. There had been a number of boats on the run, but the last steamer was the *Transport*. She was built in 1875 and acquired in 1881. Here, she is entering Rondout Creek on a Sunday morning in August 1938. (Photograph by William H. Ewen Sr.; author's collection.)

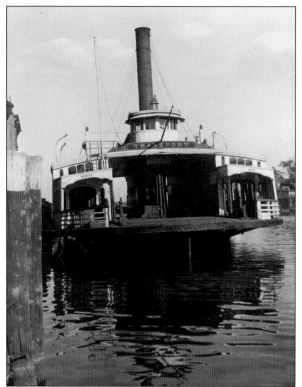

In 1930, another ferry, the diesel-powered *Kingston*, was acquired to run opposite the *Transport*. The *Transport* was used in the winter, and both boats were in service during the summer. After the opening of the Rip Van Winkle Bridge at Catskill in 1935, only one ferry was needed in service at a time. In this view, the *Transport* is out of service on Rondout Creek.

The *Transport* last ran in 1938. The *Kingston* continued until service ended in 1942. Service was restored in 1946 with a modern diesel, the *George Clinton*, and ended for good with the opening of the Kingston-Rhinecliff Bridge in 1957. The *Transport* is shown being scrapped at the Cornell shops in 1941. Cornell used the hull as a stake boat for mooring barges in New York harbor.

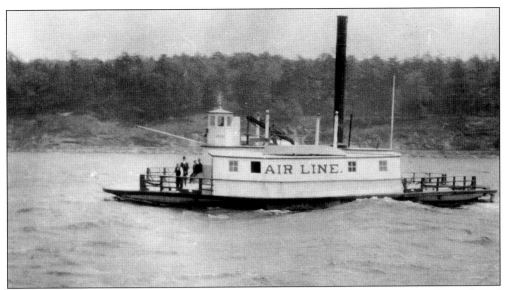

There had been intermittent ferry service between Saugerties and Tivoli during the 19th and 20th centuries, finally ending in 1938. The little side-wheeler *Air Line* was the most interesting. She was a double-ender with a pilothouse at one end and usually only ran in one direction. The boat was built for the Air Line Railroad of Philadelphia in 1857 and operated out of Saugerties between 1860 and 1915.

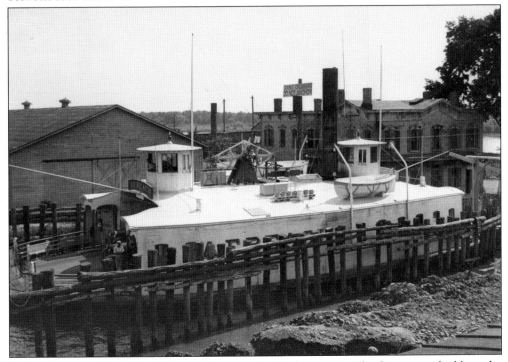

A ferry between Catskill and Greendale began in the late 1700s. The first steam double-ender was the *Catskill* of 1865. She was replaced in 1878 by the *A. F. Beach*, shown here in the slip at Catskill in 1932. She ran until September 1936. The last boat on the run was a gasoline, scow-type ferry. (Photograph by William H. Ewen Sr.; author's collection.)

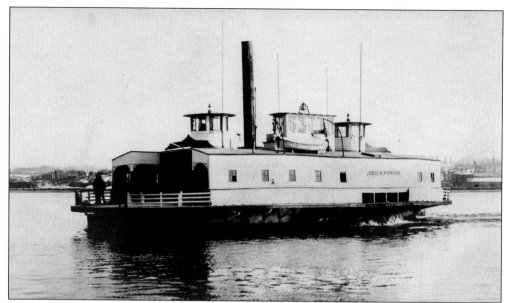

The first steam ferryboat running between Hudson and Athens was the *J.T. Waterman* of 1858. She was replaced by the *George H. Power*, seen here, built at Athens in 1869. The boat ran on the line for 52 years and was sold in 1921 for service on Lake Champlain. The Hudson-Athens ferry last operated in 1947, using a small diesel, the *City of Hopewell*.

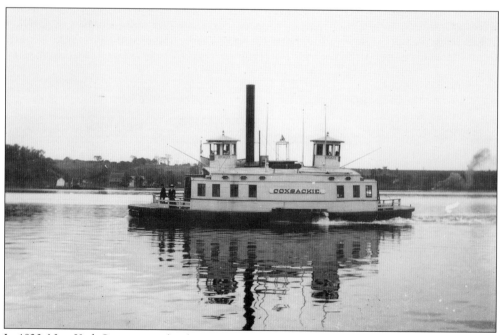

In 1820, New York State granted rights to operate a ferry between Coxsackie and Newton Hook "to be propelled by horses or other means." The first steam ferry on the run was likely the *James Reynolds* in 1861. In 1878, the little side-wheeler *Coxsackie*, seen here, was built for the line. After 50 years of service, she was scrapped at Coxsackie. The ferry service ended in 1938.

ABOUT THE
SS COLUMBIA PROJECT

Almost 35 years after the last passenger steamboat left the waters of the Hudson River, there is hope for the return of a large, authentic steamboat. The steamer *Columbia* was built in 1902 for excursion service out of Detroit. She is the oldest surviving passenger steamer in the United States and is a National Historic Landmark Vessel.

The *Columbia* was designed by naval architect Frank E. Kirby and interior designer Louis O. Keil, the team responsible for several famous Hudson River steamers, including the *Hendrick Hudson* and *Robert Fulton*.

The nonprofit SS *Columbia* Project that owns the steamer has been doing extensive work, including stabilization, asbestos abatement, fundraising, and so forth. She will be towed to the Hudson where she will be restored to operating condition. Once operational, the *Columbia* will bring the age of steamboating back to the river where it began over 200 years ago, and like the steamers of the past, she has the potential to help the economies of the area, this time through tourism.

It would be wonderful to see a large white steamboat, with flags flying, sailing up the Hudson again and to hear a chime whistle echoing over the valley. Go to www.sscolumbia.org to learn more.

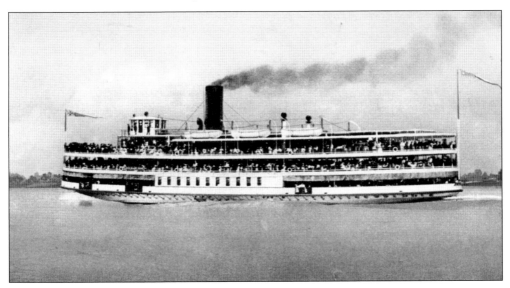

www.arcadiapublishing.com

MAP SEARCH

Discover books about the town where you grew up, the cities where your friends and families live, the town where your parents met, or even that retirement spot you've been dreaming about. Our Web site provides history lovers with exclusive deals, advanced notification about new titles, e-mail alerts of author events, and much more.

MADE IN THE USA

Arcadia Publishing, the leading local history publisher in the United States, is committed to making history accessible and meaningful through publishing books that celebrate and preserve the heritage of America's people and places. Consistent with our mission to preserve history on a local level, this book was printed in South Carolina on American-made paper and manufactured entirely in the United States.

This book carries the accredited Forest Stewardship Council (FSC) label and is printed on 100 percent FSC-certified paper. Products carrying the FSC label are independently certified to assure consumers that they come from forests that are managed to meet the social, economic, and ecological needs of present and future generations.

FSC
Mixed Sources
Product group from well-managed
forests and other controlled sources

Cert no. SW-COC-001530
www.fsc.org
© 1996 Forest Stewardship Council

Find Your Place in History.